WHAT REMAINS

WHAT REMAINS

The Suitcases of Charles F. at Willard State Hospital

ESSAY BY ILAN STAVANS
PHOTOGRAPHS BY JON CRISPIN

ee
excelsior editions
AN IMPRINT OF STATE UNIVERSITY OF NEW YORK PRESS

Cover image from the collection of photographs documenting the suitcases of Charles F. © Jon Crispin

Published by State University of New York Press, Albany

© 2020 State University of New York Press
All rights reserved

Printed in the United States of America

No part of this book may be used or reproduced in any manner whatsoever
without written permission. No part of this book may be stored in a retrieval system
or transmitted in any form or by any means including electronic, electrostatic,
magnetic tape, mechanical, photocopying, recording, or otherwise
without the prior permission in writing of the publisher.

Excelsior Editions is an imprint of State University of New York Press

For information, contact State University of New York Press, Albany, NY
www.sunypress.edu

Library of Congress Cataloging-in-Publication Data

Names: Crispin, Jon. Photographs. Selections. | Stavans, Ilan. What remains.
Title: What remains : the suitcases of Charles F. at Willard State Hospital / Ilan Stavans and Jon Crispin.
Description: Albany : State University of New York Press, 2020. | Series: Excelsior editions | Includes bibliographical references.
Identifiers: LCCN 2019030651 | ISBN 9781438478906 (paperback) | ISBN 9781438478913 (ebook)
Subjects: LCSH: Photography, Artistic. | Luggage—Pictorial works. | F., Charles, died 1950—Estate. | Willard State Hospital (N.Y.)—History—Sources. | Psychiatric hospital patients—New York (State)—Fiction.
Classification: LCC TR655 .W496 2020 | DDC 770.9747—dc23
LC record available at https://lccn.loc.gov/2019030651

10 9 8 7 6 5 4 3 2 1

ALSO BY ILAN STAVANS

FICTION
The Disappearance * *The One-Handed Pianist and Other Stories*

NONFICTION
The Riddle of Cantinflas * *Dictionary Days* * *On Borrowed Words* * *Spanglish* * *The Hispanic Condition* * *Art and Anger* * *Resurrecting Hebrew* * *A Critic's Journey* * *The Inveterate Dreamer* * *Octavio Paz: A Meditation* * *Imagining Columbus* * *Bandido* * *¡Lotería!* (with Teresa Villegas) * *José Vasconcelos: The Prophet of Race* * *Return to Centro Histórico* * *Singer's Typewriter and Mine* * *Gabriel García Márquez: The Early Years, 1929–1970* * *The United States of Mestizo* * *Reclaiming Travel* (with Joshua Ellison) * *Quixote: The Novel and the World* * *Borges, the Jew* * *I Love My Selfie* (with Adál) * *Sor Juana: or, The Persistence of Pop* * *On Self-Translation* * *The Seventh Heaven* * *The Return of Carvajal*

POETRY
The Wall

CONVERSATIONS
Knowledge and Censorship (with Verónica Albin) * *What is la hispanidad?* (with Iván Jaksić) * *Ilan Stavans: Eight Conversations* (with Neal Sokol) * *With All Thine Heart* (with Mordecai Drache) * *Conversations with Ilan Stavans* * *Love and Language* (with Verónica Albin) * *¡Muy Pop!* (with Frederick Aldama) * *Thirteen Ways of Looking at Latino Art* (with Jorge J. E. Gracia) * *Laughing Matters* (with Frederick Aldama)

THEATER
The Oven

ANTHOLOGIES

The Norton Anthology of Latino Literature * *Tropical Synagogues* * *The Oxford Book of Latin American Essays* * *The Schocken Book of Modern Sephardic Literature* * *Lengua Fresca* (with Harold Augenbraum) * *Wáchale!* * *The Scroll and the Cross* * *The Oxford Book of Jewish Stories* * *Mutual Impressions* * *Growing Up Latino* (with Harold Augenbraum) * *The FSG Books of Twentieth Century Latin American Poetry* * *Oy, Caramba!* * *How Yiddish Changed America and How America Changed Yiddish* (with Josh Lambert)

GRAPHIC NOVELS

Latino USA (with Lalo Alcaraz) * *Mr. Spic Goes to Washington* (with Roberto Weil) * *Once @ 9:53 am* (with Marcelo Brodsky) * *El Iluminado* (with Steve Sheinkin) * *A Most Imperfect Union* (with Lalo Alcaraz) * *Angelitos* (with Santiago Cohen) * *Don Quixote of La Mancha* (with Roberto Weil)

CHILDREN'S BOOK

Golemito (with Teresa Villegas)

TRANSLATIONS

Sentimental Songs, by Felipe Alfau * *The Plain in Flames*, by Juan Rulfo (with Harold Augenbraum) * *The Underdogs*, by Mariano Azuela (with Anna More) * *Lazarillo de Tormes* * *El Little Príncipe*

EDITIONS

César Vallejo: Spain, Take This Chalice from Me * *The Poetry of Pablo Neruda* * *Encyclopedia Latina* (four volumes) * *Pablo Neruda: I Explain a Few Things* * *The Collected Stories of Calvert Casey* * *Isaac Bashevis Singer: Collected Stories* (three volumes) * *Cesar Chavez: An Organizer's Tale* * *Rubén Darío: Selected Writings* * *Pablo Neruda: All the Odes* * *Latin Music* (two volumes)

GENERAL

The Essential Ilan Stavans

ALSO WITH PHOTOGRAPHS BY JON CRISPIN

Rules of Thumb: A Life Manual * *From Abbotts to Zurich: New York State Placenames* * *Fields at Work: Working Landscapes of the Champlain Valley* * *Syracuse Landmarks: An AIA Guide to Downtown and Historic Neighborhoods* * *Rules of Thumb 2* * *A Sense of Place* * *Ithaca: A Book of Photographs*

To my brother, Darián
—I.S.

To Craig Williams and Peggy Ross,
with gratitude for their help and support
—J.C.

And entering with relief some quiet place
Where never fell his foot or shone his face
I say, "There is no memory of him here!"
And so stand stricken, so remembering him.

> —Edna St. Vincent Millay,
> "Time Does Not Bring Relief,"
> *Collected Poems* (1931)

CONTENTS

1 What Remains
Ilan Stavans

49 The Suitcases of Charles F. at Willard State Hospital
Photographs by Jon Crispin

105 Memory Is a Box without Edges:
A Conversation between Ilan Stavans and Jon Crispin

111 Acknowledgments

WHAT REMAINS

Ilan Stavans

THE ANGEL WHO RELATES

It was a hot August day on Seneca Lake, right on the border bringing together the towns of Ovid and Romulus in central New York State, when a bulky, tall man of about six foot, three inches, eighty-five years of age, a savant by the name of Charles F., arrived at the sprawling campus of Willard State Hospital. The year was 1946. The emotions connected with the end of World War II were still fresh.

For someone like Charles, with a vivid life of the mind and a penchant for routine, Willard was an inappropriate place to end. A state-run hospital housing thousands of patients from an assortment of economic levels (mainly poor), one of its directors had once prophetically described it as being for "the disoriented and dependent class, who require more than a simple home. Humanity should provide *humane* treatment for those who stumble. The well-being of our society in large part depends on the care these patients get. They should not be deemed expendable, for if they do the rest of us are to blame."

How expendable—or how incurable—Charles F. was and exactly what he required in terms of treatment were up for discussion. For his age, he was extraordinarily articulate and capable of deep thinking, although at times he would be given to tantrums. He was also quite mobile. He must have led an admirable life up to that point, one defined

by a sharp, exciting mind in a state of constant engagement.

Where was everyone now, though? Did anybody care?

In the previous few years, more than at any other time before, Charles F. had gone through periods of darkness. They made him seem isolated, trapped in his own loneliness. One could say the war was partially to blame. He had been obsessed with it from the start. Not knowing about his relatives in Europe was a nightmare. Yet it was really all about age. Exciting thoughts still visited him, and he welcomed them wholeheartedly. Slowly, though, and regardless of how much he resisted, his world was clearly crumbling.

At the very least, the doctors at Willard agreed he was what psychiatry calls "a puzzling profile," a patient whose symptoms are sometimes perfectly explainable and at other times are absolutely mystifying. He was disoriented, sometimes even childish, yet he was also clever, astute, incisive, and thoroughly endearing. He didn't know anything about mental disorders. What he did know is that certain ideas, certain visions were clearer now that at any point earlier in his life.

A note in his medical dossier, dated a few weeks after Charles F.'s registration at the asylum and written by Dr. Sheldon Nuland, his primary caretaker and eventually a friend, describes him: "Restless, at times making contradictory, rambling statements. Patient displays symptoms of anxiety, despondency, and hallucinations. He also has high blood pressure. But is likewise pleasant and composed and very rational. Or rather: he is spiritual. Patient has a deep internal life; he is in dialogue with angels."

Charles F. didn't think what he had with his visitor was a dialogue. In fact, had it been left to him, he would have preferred to describe it as a lesson. Why exchange words if what he experienced was of such beauty? He mainly listened—quietly, patiently, careful not to make a fuss.

———

Upon arrival at Willard, Charles F. made a statement. It was recorded by a staff member and placed in his dossier:

My name is Charles F. I got a good name. Never said a bad word about anyone. Never in trouble. I am here for nothing at all. I live in Jamaica. I went to the subway station house and they threw me out. I refused to go, so I spit on the floor, so they locked me up. I had a good name. I don't drink. I don't gamble. I got no place to go. I was a wealthy man but I lost everything. It wasn't entirely my fault.

There is a plan for everything we do, a plan controlled by God. I am fifty years in America. Fifty. I got my papers at home. I just need to retrieve them.

He had three old suitcases with him. He cherished their contents. Those objects spoke to different aspects of his life. Eventually, they were taken away, although he regained access in a few weeks, once he settled in his room in Winslow Hall. Apparently, he didn't pack the suitcases himself; one of his daughters did. After the first week, he was frustrated not to be able to find his favorite pajamas anywhere. His Hebrew calendar was missing, too. All of this made him feel not only dislocated but upset.

And totally alone. Where was everyone he had loved? Why hadn't Miriam asked what he needed when she agreed to let him be taken to Willard? It would have been so easy. She was his daughter. Hadn't he raised her? Had he been a bad father? Even at the police station, he would have made a list for her. It wouldn't have been hard.

Like most other patients, Charles F. entered Willard through Barrett House, the main administrative building, on a hill above the lake. Over time, he moved a lot, being housed in the Southern and Northern Wings of Barrett Hall, as well in Valentine, Reiner, and Winslow. He couldn't have known it then, but his arrival coincided with the end of one of the most stable periods in the institution's history. Only a few years later, a precipitous decline began, not only in regard to the medicines and other available items—iodine, syringes, and cotton puffs were scarce then, as they had been during the war—but in terms of the overall quality of life of the patients, doctors, and staff.

This worsening of conditions was connected in part to the priorities the nation set for itself now that soldiers were back from the front. Beyond that, views of mental illness and psychiatry were about to be shaken. Long-term care for patients in psychiatric hospitals was about to be tested as a concept. At Willard, Charles F. received a type of treatment that within a couple of decades seemed utterly anachronistic.

Although he arrived in an ambulance, he thought he could have come by foot. As he told everyone, "for a Polish immigrant who arrived at Castle Garden in Battery Park without a cent in his pocket, I was still rather together." Yes, occasionally he got out of breath. His arthritis was more than a nuisance; it felt to him like a calamity he needed to escape. Yet he wondered if there is ever a point in life at which humans do not suffer. To dispel the pain, he could count to one hundred in Hebrew. Or was it Polish?

"Suffering is good," he would repeat to himself. "It builds character. *Hazak, hazak, venit'hazek*—be

strong, be strong, and we will be strengthened. It is how every book of the Torah concludes, with the end of *Pekudei*. Suffering heals the soul. Suffering helps focus the mind."

His Jewishness would ultimately save him, he believed. As far as he was concerned, he was at Willard only temporarily, just as he had been in the previous hospital. What was its name? He couldn't remember. The name "Willard" he couldn't recall, even though the word had a nice ring to it. Hadn't he heard that it was on the Seneca River, upstate? He had been to Syracuse twice, once to see a client. He and Leah had taken the children for a vacation that included the Erie Canal. He knew Seneca was a Roman philosopher. Wasn't he the author of *Naturales Qauestiones*, explaining the causes and secrets of how nature works? A friend had told him about it after reading a copy at the New York Public Library midtown branch.

Even though these comments were positive, Charles obviously preferred not to be at Willard. That's because he wasn't crazy—of that, he had no doubt. Other people were, but not him. He would leave the next day or the one after. Ida was about to return from Florida. He had promised to join her in the Catskills in early September, when it is less humid and the crowds are gone. He always kept his promises.

Charles F. never left Willard, though. Nor did his suitcases. At one time the nation's largest asylum of its kind, Willard swallowed him whole, just as it did the other 50,000 patients it housed in its 125-year history.

It wasn't solely his fault. Friedrich Nietzsche liked to argue that "in individuals, insanity is rare; but in groups, parties, nations, and epochs, it is the rule." In broad strokes, culture was to blame, since it just didn't know what to do with people like Charles F. Are they still of some use? Hadn't the asylum's founders cautioned against finding such a population expendable? The mind is a volatile machine. When it works, it does so in predictable ways. But then, *boom!*, nothing makes sense anymore. What we call mental illness is just chaos.

At what point does our life cease to be ours? When do we lose control of it? Does it ever really belong to us?

Three months before his admission—three months and two days, to be exact—Charles F. found himself in Brooklyn. He couldn't tell exactly why. And at Union Street? He never used that train station. Was he on his way to Williamsburg to visit a

supplier? But he no longer had any. There must have been another reason.

Was he about to meet Ida Shanholtzer? Impossible. Not only was she with her cousin that day, her apartment wasn't in Gowanus but in Jamaica, Queens. What could she be doing in Brooklyn, too? It was all very strange. In fact, he preferred to walk places instead of taking the subway, partly because he could no longer afford it.

Disheveled and malnourished, sitting alone on a bench, Charles F. was wearing his old black pants, a white shirt, a heavy black winter coat, and a pair of broken leather boots. At some point earlier that day, he had a yarmulke on his head, but he had lost it. He kept repeating a few words in Russian. Polish? Or was it Yiddish? He couldn't distinguish between them anymore.

"You're demented, Papa!" Esther, his daughter, would say. "*Bonkers*! That's what you are. Bananas!"

He didn't know it, but it was the beginning of the end. The usual rush of adrenaline in the morning stopped him from realizing that his time was up, that fate had turned around and there was really nothing he could do. He was useless. Old and useless and empty of dreams that once moved him forward.

Every time another train stopped, the stream of passersby at the station ignored him. Until a young lady, pretty and coquettish, maybe around twenty-five, with a French accent, stopped near him. She asked if he needed help. Did he? No, thank you. He didn't think he did. But had he actually responded? He wanted to tell her she was kind and compassionate and ask how her day was, but she was in a rush and no words would come out of his mouth. Inexplicably.

On her way out of the subway station, the young lady alerted a police officer, explaining that a rugged old man, sitting near the tunnel on a wooden bench at the end of the station, looked lost. Maybe he was a refugee from Europe? There were lots on the streets those days. He looked like a person who hadn't eaten a good meal in days, perhaps weeks.

On his notepad, the officer wrote down the time—11:18 a.m—and scribbled a few words. Minutes later, he was joined by a colleague, and the two descended the staircase and made their way to the end of the station. After spotting the man, one of them gently put his right hand on the gun hanging from his belt.

They asked him a question, two, three. Because Charles F. wouldn't respond, they concluded he was deaf.

"DO YOU KNOW WHO YOU ARE?"

He spat on the floor, then kicked a garbage can. Babbling, his eyes lost in the light coming from the

other end of the station, Charles F. said he was in Gowanus, a few blocks away from the intersection of 3rd Avenue and DeGraw Street. He knew exactly where that was. He had simply forgotten why he had come.

If he needed, one of the officers said, they could take him home, to which Charles F. just laughed out loud and then started screaming. Then he stood up, visibly annoyed, and asked to be left alone.

He was from Jamaica, he said.

"You don't look Caribbean."

"Not the island of Jamaica. Just Jamaica. In Queens. And thank you, but I know my way." In fact, he was waiting for a train to get back to the city. He didn't want to be late. He had lots of things to do, and it was getting late.

A few minutes later, when asked what his name was, Charles F. said Ya'akov, as in the Bible, and like his brother in Europe. He paused. Yes, Ya'akov ben Yitzhok from Vitebsk, Belarus. He hadn't heard from him since the beginning of the war. He hoped it was all fine. No tragedies. He surely didn't want a tragedy.

"WERE YOU A SOLDIER?"

One of the officers could see a canteen under Ya'akov's coat. But he looked too old to have been in the battlefield. Had he perhaps fought in World War I? Was he a refugee?

"Me? No, not me. My son Benjamin was. Benji."

The other policeman pushed for more information about Ya'akov's home in Jamaica.

"95th Avenue."

"There is no such avenue. You mean 93rd Street, 157–42?"

"Yes, officer."

"Are you Charles or Ya'akov?"

"Yes, Chaim or Ya'akov."

In his notebook, the police officer wrote down the world *disoriented*. He insisted on referring to him as Chaim F. (In Hebrew, the word, also spelled *Haim*, *Hayim*, and *Chayim*, means life.) He scribbled "Mrs. Shanholtzer in Miami Beach, Florida," whom Chaim F. kept now referring to. Finally, he wrote that it wasn't Ya'akov but Chuck. Or Charles. That's what the old man said his name was. Last name? Frankel, Franklin, Frankenhaimer? Not sure, so with a sense of disbelief, the officer simply wrote the initial F., which stuck for some unexplained reason. From this period on, people who knew Chaim simply called him F.

Close to noon, Chaim F. was transported to a police station on Bedford Avenue in Williamsburg. A few phone calls later, an adult about forty-five years old

showed up. His name was Mo, and he identified Chaim F., as in Friedlander, as his father, although it later turned out that Friedlander wasn't the right last name. Was the man not his son, then?

Mo said his father was divorced and lived with a girlfriend, Ida, in Jamaica, Queens. But the girlfriend no longer wanted him because he often experienced visions. She was scared of him. Mo said that once, while his father was shouting, he threatened to kill Ida. "He is demented."

Chaim F. was alone in a cell. Half an hour later, a daughter, Esther, a bit younger than her brother, also arrived at the police station, showing signs of being distraught. She said she lived in Brooklyn, on Avenue N, and worked in the can factory at the intersection of 3rd Avenue and 3rd Street. She had been waiting hours for her father to arrive. They had agreed to meet at 9:45 a.m. It wasn't uncommon for him to arrive late. But he always made it. Had he killed anybody? When she heard from Mo that her father was under arrest, she feared the worst. He was no longer capable of caring for himself. But he was very stubborn. And the family didn't have money for doctors.

Esther said her father talked of being visited by the Maggid. "I'm a proud confidant of the Maggid, the guardian whose actions make the universe pure." She didn't know what that meant.

"He is a devout man who loves stories."

Esther said he believed that God oversees all earthly matters but at times disappears—missing in action—for people to take control of their own destiny. She said Charles loved baseball, too. "It's therapeutic. Mickey Mantle and Joe DiMaggio but especially Ted Williams. The Yankees, the Brooklyn Dodgers, the New York Giants. He memorizes the statistics. Every single one. Who played who. Who was at bat. Who hit a home run in what inning and so on and so forth. Lots and lots of numbers."

She knew the police didn't have time to waste, but when the children were little, their father told them all sort of tales about the shtetl in Poland where their ancestors came from.

She explained, "His anxieties take control of him. On any given morning, he works up a sweat. He screams uncontrollably for an hour or so. Even the neighbors are scared. But then, when he's relaxed, he doesn't remember a thing. Not one . . ."

She said her father went by several names: Chaim, Chuck, Ya'akov, and even Ebenezer. But mostly Charles.

A psychiatrist was called. An hour later, he visited Charles F. in the cell. At this point, he was even more disoriented. "It is better not to remember the name of Leah's husband, since he was a conniver," he said. He added that he had been a legal resident of

New York City for sixty-five years. That was home; it would be forever.

The next day, Charles F. was transported to the Hudson River State Hospital, in Poughkeepsie, New York. The admission date was July 17, 1945. His dossier describes him as "senile." It describes him as digressing "about his brothers in Europe, who might be dead but he doesn't know it." Since the sanatorium was full, he was soon deemed to be "transferable." But no other asylum had available beds, so he needed to wait for several weeks.

Only later, when he saw in a newspaper that the Cincinnati Reds had beaten the Brooklyn Dodgers 10–4, Charles F. remembered that he had meant to buy tickets for a New York Giants game. He found out that on the day he went to the asylum on the river—what was it called?—is beloved Red Sox slugger Ted Williams had been offered $500,000 to play in the Mexican baseball league. That's a huge amount: half a million dollars. What can anybody do with so much money? He was proud to have seen Williams play a bunch of times. He loved the way he swung the bat, like a dancer in a ballet.

He had a few Williams baseball cards, which he had purchased a number of years before. One was often in his pocket. Why couldn't he find it now? Was it stolen by one of the police officers? Is that why they performed that uncomfortable search? Or did the search take place previously?

He couldn't say for sure. At any rate, the Ted Williams card was gone. This made him sad. Very sad.

———

Charles F. was admitted to Willard on Friday, August 9. He was cataloged as patient #76086. In total, he stayed there a bit less than four years, which can be divided into two chapters: before the crisis and after.

The first chapter opens with a thin, almost empty dossier that incorporates what doctors and nurses at Hudson River State Hospital had stated about Charles F.: that he was anxious. And maybe deaf, too. That when he talked, he often rambled, but he had lucid moments. Since he had complained of arthritis, he was also diagnosed with psoriatic arthritis, although it most likely was the garden variety osteoarthritis. The dossier contains transcriptions of interviews with doctors, reports of behavioral patterns, and addresses and phone numbers of family and other relatives.

In spite of his fragility, in the mornings he milked the cows. He wanted to be active. His body was old, but his soul was youthful. Willard was

known for its farm products. It included "the piggery" and "the hennery," but dairy was the primary focus. The previous year, the milk production was 727,572 quarts and the next year, the average production per cow was 12,000 pounds of milk a year. Charles F. didn't have experience with cattle. Even when he was a child, he had always lived in an urban setting. In spite of his age, he took to these tasks with enthusiasm.

With time, his dossier grew, in part because his diagnoses changed. The first doctor's note written at Willard is dated August 10. It states:

> Transferred patient. Hears but doesn't listen. Erratic at times but very intelligent. Pleasant in the morning. Doesn't seem to know he is a patient at Willard. Loves baseball. Can talk about it all day. Jewish. Has three suitcases, which he wants next to him. He spent time at Valentine and Reiner. And was at the Marconi men's infirmary. Talks of his daughter Esther picking him up in the afternoon, or maybe after dinner.

Three days later comes a note from August 12:

> Patient was said to be agitated in previous institution. He was pleasant now, cooperative, alert but withdrawn. Emotionally he was cheerful. He was diagnosed with DEMENTIA.

He had suffered from radical mood swings and behavioral upsurges for years. People suffering from it were sent to Ward 5 in Barrett Hall, on the Northern Wing, where Willard's most troublesome patients went.

Within a short time from his arrival, Charles F. changed locations again. Expectedly, the move increased his anxiety. At various hours of the day, he was heard shouting, "The Maggid is angry! The Maggid is mad!" Several nurses talked with him until he was relaxed. He told them the Maggid was an angel who could communicate with his brothers in Poland. He could even save them.

"*My* angel."

In retrospect, of Charles F.'s journey through Willard, the most significant aspect is his relationship with Dr. Stanley Nuland, one of the chief psychiatrists and a researcher on extreme manifestations of dementia, who was also of Jewish background. In his mid-thirties, Dr. Nuland was married and had two children, a boy and a girl.

His wife, Leticia Lawler, was originally from Texas. They had met in Chicago. She worked at the Ovid County Courthouse.

Most of what is known about Charles F. at Willard comes from Dr. Nuland's notes. He had trained at the University of Chicago. He had published several papers in prestigious journals, including the *American Journal of Psychiatry*, about behavioral genetics and modern approaches to neurasthenics since Freud's early case studies.

While Dr. Nuland was intensely busy, with scores of patients to attend, his interactions with Charles F. made a strong impression on him. Charles F.'s hallucinations, according to him, were manifestations of deep thinking by the patient, and the staff needed to patiently understand their logic. He believed it counterproductive to look at every event related to dementia as outtakes of chaotic thinking. In religious patients, those incidents frequently contained the essence of the person's take on life.

They became well acquainted with each other. In their early conversations, Charles F. told Dr. Nuland that he was "a silent man." When pressed to explain what he meant, he said he made no claims to fame. He had started as a peddler. He built his own shoe store from scratch and had it for a long time. A block from Lombard Street. What street? A shame that he could no longer remember. The store had made him wealthy, but then it all collapsed.

After the divorce, he was a boarder in Jamaica. He lived in several private homes. But then, Charles F. didn't remember how he lost everything. He spent a lot of time in the main waiting room of the Jamaica Railroad Station. He had been born in the Russian provincial capital of Vitebsk, where Marc Chagall was born, too, as well as Shloyme Zanvl Rappoport, better known as S. Ansky, the author of the famous play *Der Dybbuk*. Jews didn't move much then, unless they were looking to emigrate, but Charles F.'s family did wander around because his father had family in central Poland. He grew up in Łódź. Growing anti-Semitism. Some siblings had already moved, one to Palestine, several others to New York. He followed the latter.

Charles F. said he had four children: Benjamin, Mo, Esther, and Miriam. Benjamin died from poison gas years ago on the battlefield of Verdun, in France, in November 1916. Upon first arriving in America, he and his wife, Leah, had been helped by one of her siblings, a peddler. For a while, Charles F. sold merchandise in the Lower East Side. The family lived on Lombard Street. When he walked around with the goods for a few blocks, he could see the Williamsburg Bridge. He loved the bridge; on a clear day, it reminded him of Belarus.

On Thursday, October 17, Charles F., in the hallway of Marconi Annex, told Dr. Nuland that he worked in the kitchen three mornings a week. He also was ready to help with the garden in the spring. He had heard that Willard had just hired a new gardener, Gerineldo Márquez, who, when he was young, had worked as a fisherman in Veracruz, catching red snapper.

This reminded him that he had met Leah Lerner on a boat. A teacher's daughter originally from Podolsk, she was three years younger than he. They entered the United States through Castle Garden, eventually named Ellis Island, in 1880. The boat trip across the Atlantic, lasting over three weeks, was penurious. They ate boiled potatoes and drank hot water. There was not even salt on the boat. They didn't have medicine. A young man got pneumonia and after three days died on board. When he and Leah looked at New York City, they cried. He remembered having seen a photograph in newspapers in Łódź.

According to the dossier, around that time, in late October and early November, Charles F. seemed to be having a lucid period.

"I was twenty years old when I passed through Castle Garden," he told Dr. Nuland. "Mister Rutherford B. Hayes was the American president. I memorized the census: there were 50,155,783 people in the United States. Leah and I would be the 784th and 785th. The country's first telephone service was installed in New Haven. The Panama Canal construction was begun. And the first game of professional baseball took place, at the Polo Grounds, between the New York Metropolitans and the Washington Nationals. The Metropolitans won 4–2 in five innings."

Dr. Nuland usually met Charles F. in his office at Winslow Hall, on Stewart Road, not far from the morgue. The patient liked "the silence of the morgue." He found it suiting.

"I'm not deaf," he would say. "I can hear perfectly. And sometimes I can hear what the corpses say to me when I go by the morgue. They want me to pay attention to them. They have not yet departed. They are souls that are still with us. It takes eight days for the soul to abandon the body. Eight. In those eight days, people can still talk. They want their last thoughts to be heard."

"What do they tell you, Charles?"

"That death isn't the end. There's a period of waiting. Of reckoning. Even after the eight days, souls need to present their case before the Almighty. As in a court case. They need to prepare the paperwork."

He then changed the subject, saying he and Leah had lived in a tenement in the Lower East Side. At

first he worked in a sweatshop. Then he got a job as a tailor. He and Leah divorced in 1915, when he was fifty-five. He hadn't seen her for years. "She and her husband stole money from me," he repeated. He also mentioned that he had started having dreams in which he would see three of his older brothers. They looked as they did when he said goodbye to them decades earlier. They didn't smile; in fact, they looked unhappy.

A careful, considerate man, Dr. Nuland had a rigorous scientific mind, yet he never looked down on spiritual matters or saw them as manifestations of fanaticism. He had heard from a nurse that Charles F. prayed every morning. From the moment he arrived at Willard, even if he thought he would be leaving in a matter of days, he had kept his phylacteries in their own velvet bag, a prayer shawl in its special container, and a yarmulke. He had a Hebrew version of the Bible and three *Sidurim*, as the Jewish prayer books are called.

He always prayed in the morning and before going to bed.

On Saturday, November 23, during a small Shabbat lunch he organized, Dr. Nuland asked Chaim F. if he had been religious since an early age. The following transcription appears in his dossier:

CHARLES F.: Since I left Łódź.... Everyone was. My mother and father. My two brothers. It was a way to keep the devil at bay.
DR. NULAND: What could the devil do otherwise?
CF: Find how to enter you.
DR. N: What do you mean?
CF: Take control. Even when I stayed with Ida, I almost ran the risk.
DR. N: Who is Ida?
CF: My friend, Ida Shanholtzer.
DR. N: When did you meet her?
CF: I don't know.
DR. N: Where does she live?
CF: In Jamaica. 145–03 88th Avenue. We met before the war started. I sometimes forget my phylacteries bag there. I have to rush back to retrieve it before Thursday mornings, otherwise I can't pray. And without prayer, there is no lifeline. It ennobles the soul and safeguards against *Yetzer ha-Rah*.
DR. N: What is *Yetzer ha-Rah*?
CF: The Evil One.
DR. N: Has it done anything to you?
CF: No. I protect myself. I sing the liturgy.

In another conversation, Dr. Nuland asked him more about his faith. "I don't think what I do is dictated from above. We are responsible for our actions.

But the Almighty pays attention. He rewards and punishes."

Whenever Dr. Nuland left work at Willard to return home to his family, he would think about his patients, particularly Charles F. He had empathy for him, maybe even affection. He reminded him of an old uncle on his mother's side who lived in Los Angeles. Something about his demeanor, the way he walked, with his feet at an angle that made him look like a duck. In his childhood, the uncle had visited several summers. He would bring presents for everyone.

Dr. Nuland's father was Jewish and his mother, Catholic. This had generated occasional tension between them. His father didn't know much about religion, but he was attuned to the plight of Jewish fighters in British-mandate Palestine. He believed it important for Jews to get their own nation like everyone else, although he was against assassinations, bomb explosions, and other forms of terror in Jerusalem.

Somehow, Dr. Nuland wished he himself cared about these and other Jewish issues. He felt closer to his mother's faith. In fact, when he was a psychiatry student he didn't like being recognized as Jewish by teachers when they went over class lists. Surely it would hinder his chances to advance professionally. Yet in all honesty, he felt admiration, even envy, toward Charles F. Not only was he relatively robust, spirited, and on occasion even exuberant at such an advanced age, he showed a genuine connection with the spiritual world. Dr. Nuland wished he had a connection like that. He was happy in his career. His family gave him enormous joy. But he also felt too sheltered.

He was a scientist through and through. He liked observing human behavior, analyzing its patterns, explaining it based on his knowledge. All this was fine and a bit cold. He remembered the transcription of a sermon by the canon of Westminster Abbey, Frederick Lewis Donaldson, about the "seven social sins" afflicting modern man:

Wealth without work
Pleasure without conscience
Knowledge without character
Commerce without morality
Science without humanity
Worship without sacrifice
Politics without principle

Rev. Donaldson had nailed it: not to go through life like an automaton, you needed conviction, you needed integrity, you needed gusto.

Aside from genuinely wanting to know how Charles F. carried himself through the day, what

made him happy, and what annoyed him, what Dr. Nuland was after during their conversations, in part, was investigating who the Maggid was. In his own upbringing in Chicago, he had heard this term used in relation to a distinguished teacher. Maybe Charles F.'s reference was to a formative figure in his childhood. But the way it came out, the sense was mystical, in connection with a higher spirit. Whenever Dr. Nuland pressed the topic, Charles F. changed the subject.

One Friday in December, he finally talked to Dr. Nuland without subterfuges, saying that the Maggid was "the angel who relates." He added that the Maggid "also passes secrets on to me while I'm asleep. He makes me write without my knowing, as if I were a secretary. He asks me to take no pleasure in this world and wants me not to eat food, but I'm hungry so I disobey him."

Dr. Nuland pressed Chaim F. to make a fuller portrait of the Maggid. Charles F. demurred. But finding himself in a sudden trance, he said:

> He is tall and his cloths are made of linen. His face is fire. He has enormous wings. Six in total, like the angel Isaiah saw. The wings are white and fuzzy. I feel the temptation to touch them but hold off. His face is feathery, too. Like a falcon. He enters through the window. Or through the door. But he can trespass walls, since his nature is wraithlike. . . . He is like the angel guarding the Tree of Life in the Garden of Eden. Or perhaps like the three angels who visited Abraham after his circumcision. Or the one that stopped Abraham from sacrificing his son Isaac. But not like the angels that walk up and down Jacob's ladder and the one Jacob wrestled with.

These comments amazed Dr. Nuland and worried him. He had noticed that since Charles F.'s arrival at Willard, his state had improved. He became anxious less often. Probably the medication he was being given was appropriate. And the relationship with Dr. Nuland surely helped as well, giving the patient a sense of belonging.

But then the transcripts in the dossier change tone. Dr. Nuland noticed in the patient a proclivity to talk about "ethereal matters." Sometimes in the middle of their conversation, Charles F. would look as if he was distracted, absorbing energy from the sun coming through the window.

As always, Dr. Nuland scribbled some notes and inserted them in the dossier. In them, he stated that Charles F. became exhausted after their dialogue and would not talk any more. One of the nurses stated

that he slept for almost eighteen hours that night. He walked near the Willard cemetery and around the garden where tomatoes, lettuce, potatoes, carrots, and strawberries were planted by patients.

In the dossier, there is a transcript of another, more extensive interview that took place in mid-December of Charles F.'s first year at Willard:

DR. NULAND: Are you happy here?
CHARLES F.: I don't know if I feel happy. I want to go back to Jamaica.
DR. N: Are you unhappy?
CF: I don't know.
DR. N: Do you know where you are?
CF: At Willard.
DR. N: Do you know why?
CF: Because there's a plot. Some people want me behind bars.
DR. N: Why?
CF: I don't know.
DR. N: Do you feel downhearted?
CF: Yes.
DR. N: Who is the Maggid?
CF: A celestial being.
DR. N.: Does he visit you?
CF: Yes, he visits me.
DR. N: Can you talk about the Maggid?
CF: There's nothing to say.
DR. N: How does he look? What appearance does he have?
CF: (*Words in a foreign language*.)
DR. N: Do you sleep well, Charles?
CF.: I do.
DR. N: Do you dream?
CF: Yes.
DR. N: What kinds of dreams?
CF: In one, I am in my childhood house in Łódź, with my parents. This was long ago, before I came to America. I can't open a window in back. My mother was trying to help.
DR. N: You are from Łódź? I believed . . .
CF: No, from Vitebsk. But we lived in Łódź.
DR. N: Were you frightened?
CF: Yes.
DR. N: Did you wake up?
CF: Yes, I couldn't breathe.
DR. N: What did your mother look like?
CF: I don't know.
DR. N: Do you hear voices?
CF: Yes, sometimes. They speak to me.
DR. N: In English?
CF: No, in Yiddish. (*Words in a foreign language again.*)
DR. N.: I don't understand you.

CF: I came to America.

DR. N: I know. You are in America.

CF: Yes.

DR. N: Why do you pray? You pray in the morning and evening.

CF: I always do.

DR. N: Do you communicate with God?

CF: Always.

DR. N: What do you say to Him?

CF: I ask Him to take me home.

DR. N: And does God respond?

CF: Yes. All the time.

DR. N: What does God say?

CF: I will get home soon.

———

In the first week of December of that year, Charles F. made even more frequent references to the Maggid. Nurses and other patients heard about specific visitations he had experienced, mostly at night. When Dr. Nuland asked him if it was the Maggid who had come, he said it was a voice he listened to by day and a shadow that accompanied him at night, though the shadow could appear during morning prayer. The Maggid was teaching him secrets. He said these secrets came directly from Rabbi Joseph Karo, who wrote the code of Jewish law.

On one of his weekends off, Dr. Nuland, by then feeling quite close to Charles F., inquired among some friends from the Lower East Side about Rabbi Karo. He found out that Karo was a sixteenth-century rabbinical leader who died in 1575. When he returned to Willard, he was eager to talk to Charles F.

The dialogue they had was fruitful, at least in Dr. Nuland's view. The doctor learned that before he reached the age of thirteen, Charles F. had been enrolled in a yeshiva, a religious school. This possibly meant that his encounters with the Maggid were a link to that early period.

These types of exchanges recurred. Several weeks went by. Winter gave way to spring, and then came summer. Dr. Nuland again tried engaging Charles F. on the topic of the Maggid. But Charles F., who clearly was going through one of his most rational periods, had other ideas in mind.

In the dossier comes the episode titled "Bontsha."

Judging from the content, it seems as if by this point Dr. Nuland had almost totally surrendered all pretense of scientific comments about his patient. He surely was aware that other staff—doctors, nurses—would look at the dossier. Yet he isn't scientific anymore and, from the writing, doesn't appear to care about it. In the style, it is possible to detect a narrative breath with moments of evident creativity. There also appears a sincere thirst on his part to

learn about Jewish fairytales, as if, while listening, Dr. Nuland was becoming Charles F.'s pupil.

The Bontsha episode goes like this. One afternoon, Charles F. and Dr. Nuland walked near Gibson Creek in the direction of the power station and the fire house. Charles F. limped a bit. He complained of his joints, especially his knees. During the stroll, the patient, visibly exalted, suddenly recalled a legend he had heard a long time ago. It was in Yiddish and dealt with a man called Bontsha.

" 'Bontsha' means silent," said Charles F.

Throughout his entire life, Bontsha didn't speak at all. He didn't even cry when, during his circumcision, the *mohel* made a wrong move and the cut left a scar. He didn't say anything when he was abused in his first job and in all the subsequent jobs he had. When others abused him, he was silent. "Even when his wife cheated on him . . ."

He decided not to have children, since it would have required talking on his part. Improving his living conditions would also need some thought. So Bontsha died quietly, too.

Except that soon after he died, when Bontsha the Silent—*Bontsha Shveig*—made it to the heavenly chambers, he was received enthusiastically by angels and cherubs, by Avraham Avinu, even by the Almighty himself. The doors were wide open for him because he was a *Lamed-Vavnik*, one of the thirty-six *Tzadiks* (just souls) every generation contains for the world to continue.

In heaven, the Divine Court evaluated Bontsha's action. He was praised for having had a pure soul, for never deviating from the righteous path, for retaining his faith even in the face of tragedy. Bontsha listened to the court argument for the defense but again said nothing. When it was time for the prosecution to make its case, he showed some anxiety, but not a squeak came out of his mouth.

"The Almighty, too, seemed to be waiting for the prosecutor's argument," said Charles F. "It came in a mysterious way."

He said the prosecutor announced that since Bontsha had been silent throughout his existential journey, the prosecution would also be silent.

At first bewildered and then overwhelmed with joy, the Divine Court concluded its evaluation by granting Bontsha any wish he had for the afterlife.

"He could choose even the wildest wish," said Charles F. "Like being with his treasonous wife again." He paused. "Do you know what he chose?"

Dr. Nuland said no.

"Everyone in the Divine Court was quiet. Bontsha looked around. He gasped and said: *Ta-ke*?"

"What does *Ta-ke* mean?" Dr. Nuland wanted to know.

"In Yiddish, the word means 'really.' So the Almighty too said *Ta-ke, ta-ke*, really, really. To which Bontsha responded: "Since I am granted any wish I want from Heaven, I want every morning to have baked bread with fresh butter."

It was fortunate that the friendship between Charles F. and Dr. Nuland was quite solid by the time his crisis—what the dossier describes as "the suicidal fit"—took place, to the point that the doctor considered inviting the patient for dinner at his home one evening. That way he could meet his wife, Leticia. The more he thought about it, though, the more unsure he was on whether to invite him.

Might Charles F. have a fit? If he did, what would the children think? Would he need immediate help? He had invited two other patients a few months back, but their diagnoses were milder in comparison.

Dr. Nuland decided not to decide. He would wait and see how Charles F.'s condition evolved.

At 1:35 a.m. on Shabbat, July 26, almost a year after he came to Willard, the nurses on Ward #3, Barrett Hall, in the Southern Wing, where Charles F. was staying at the time, heard a loud noise in his room. One of them rushed to it and opened the door as fast as possible. Patient #76086 was on the floor. He was only partially conscious. A few feet away was a wooden chair, which he had stolen from the kitchen the night before. In the fall, he had broken a leg. Blood was pouring from his forehead.

Charles F. had had a belt around his neck. It was the belt he had arrived at Willard with, which he often kept in one of the suitcases. He had tried to hang himself.

Dr. Nuland was befuddled. No matter how anxious he seemed, it had never crossed his mind that Charles F. could consider such an option, since for a devout Jewish man, suicide is against God's order. He concluded that the patient had again lost all sense of self.

Dr. Nuland was told that Charles F. had had a seizure as he was rushed to Marconi, where the emergency room was.

Several nurses loosened his belt and shoelaces. A pillow was put under his head. He was turned to his left side. The patient Dr. Nuland saw when he arrived, though, was not the person he had been in conversations with. Charles F.'s color was ghostlike, and he was sweaty. He looked as if for hours he had been under a cold shower.

Man Digging

Everything I have written about Charles F. is a lie.

I have never seen his medical dossier; actually, I don't even know if there is one anywhere. I don't know if he lived in Jamaica, if he got lost one day at the Union Street subway station in Brooklyn, if he was a tailor, if he had a wife or children and if one of them died in World War I; I don't even know if he believed in God.

There was no Dr. Sheldon Nuland either. He is a concoction, as is his attempt to humanize Charles F.

The same goes for Willard State Hospital. Although a real state mental hospital existed in that location, the real one seemed unappealing to me: too blunt, too unbending, too much like a movie set. The world is real, and we are bound to live in it. But nothing stops us from imagining an alternative world, less stringent, more malleable. I am not a historian. Therefore, I have not just imagined Willard, I have renamed every aspect of it: its buildings, its scenery, its staff. I am in full agreement with Ralph Waldo Emerson that fiction reveals truth that reality obscures.

Of course, a lie is not the same as an untruth. There's the truth of facts, the empirical truth. Then there's the truth of fiction, the artistic truth.

There was a Willard State Hospital, on the banks of Seneca Lake, right on the border between the Ovid and Romulus in central New York. Although in its history the institution changed names a number of times (it was originally known as the Willard Asylum for the Chronic Insane and finally as Willard Psychiatric Center), people mostly just called it Willard.

A certain Charles F. arrived in 1946 and never left the institution. I looked for anyone who knew him, to no avail. Yet he was as real as his hero, ball player Ted Williams. But Emma Bovary of *Madame Bovary* was real, as was Captain Ahab of *Moby-Dick*, and Colonel Aureliano Buendía of *One Hundred Years of Solitude*. Like these invented characters, whose internal life is often more tangible to us than the people who surround us, Charles F. was a stoic sufferer.

What remains of the man? Nothing. Or almost nothing. Just the three suitcases he entered Willard with. I have seen them with my own eyes. They are stored in big boxes in a labyrinthine warehouse in Rotterdam, New York. The warehouse belongs to the New York State Museum in Albany.

Each valise contains several objects, between six and eighteen. I've touched those objects, too. I caressed their surfaces to get a tactile register of the wrinkles time has exercised on them.

One of the suitcases is made of brown leather. The other two are black: one is a steamer trunk, with a mini-closet on one side and three drawers on the other; the third has an interior lining and, as the maker's statement guarantees, is "made of 3-ply veneer, vulcanized high-fiber." All three suitcases have straps and locks. At some point, there must have been a key to each of them, but those keys are no longer part of the contents and are lost.

How I came to Charles F.'s suitcases and the man himself is a story at once circuitous and serendipitous.

It happened as my own father was approaching death. Throughout his life he had been a charismatic and vital man with energy to spare. Short and slim except for the cute belly he developed in his old age, he was always on the move, talking to people, going places, exploring the world around him. He continued to exude energy into his mid-eighties, even when he knew, as did the rest of us, that his time was limited as a result of his declining health.

I loved him dearly.

Around that time, when he would go in and out of hospitals, the image of a man with wings came to me. Somehow I wasn't thinking of an angel, at least not at first. My father hadn't been an angel. He was a complex, contradictory man. The wings weren't a symbol of sainthood.

Even when my father was in his last moments in a medically induced coma and I was at his side, whispering comforting thoughts into his ear, I had the impression that should the nurses be able to turn him, I would have seen the magnificent wings: human-size, graceful, intricate in their feathery surface, with undulating tones of whiteness. If I wanted, I could have touched them with my fingers.

It is strange how, since then, whenever I think of my father's end, the wings insist on making an appearance. Maybe I didn't imagine them. Maybe he had indeed grown them on his back in his last few days.

Physically, Charles F. wasn't at all like my father. And his story couldn't have been more different, since my father wasn't an immigrant from Eastern Europe, like his own parents had been. Yet they shared a joie de vivre—the impetus to experience every moment in its full intensity.

I was sitting one afternoon at a café with my friend, photographer Jon Crispin. He was showing me a sequence of photographs he had been taking of what he called "the Willard suitcases." The pictures showed valises belonging to patients at Willard State Hospital, a psychiatric hospital in central New York that had shut its doors in 1995. Crispin described how for seven years, he and his assistant, Peg Ross, would open up each suitcase, their contents put on display on a seamless background to be photographed in a sequence of ten to several hundred pictures.

I found the sequences breathtaking. There was something magical about them. Although the owners of the items in the suitcases had died long ago, it was clear their artifacts told powerful, emblematic stories on their own. You could instantly imagine that the lady in the beautiful flower dress was joyful if a bit shy and that the music she liked to dance to, from the jewelry she wore, was the foxtrot. Or that the owner of a hundred books perceived himself as an avid adventurer of unexplored regions who was rather paralyzed by the mere thought of leaving his room for breakfast in the morning. Or that the black army soldier in the black-and-white portrait had suffered a life-shattering wound at war that caused him to limp until he died and left him psychologically scarred.

In 1985, Crispin had done a similar project, documenting four New York state abandoned asylums. The project was called "Silent Voices." He looked for the emotional side of objects that had been left in those buildings. This more recent series was another variation of his passionate effort to rescue the lives silenced by confinement.

At one point, a specific sequence of photographs about a religious Jew popped up in Crispin's laptop. There were neatly ironed shirts. A twisted belt. A clean army canteen and its canvas cover. A Passover *Haggadah*. Carefully kept envelopes and stationery paper. There were tools, like a hammer and tweezers. There was a date book, a needle and thread, and a black-and-white portrait of a young man. There was a shaving set and a loose frame. And there was religious paraphernalia.

The name *Charles F.* was inscribed on several items. Crispin told me that as part of the agreement with the museum where the suitcases were stored, he wasn't allowed to reveal the person's full name.

I felt a jolt, a sense of instant connection, a feeling of empathy. In terms of strength, none of the other photographic sequences generated a similar

reaction. Maybe it was the religiosity of the owner of these suitcases that spoke to me loudly.

In the months that followed, I looked for anything I could find about Willard. I found out about the arrival of the first admitted patient. It was in 1869 and her name was Mary Rote. Described as "demented and deformed," full of anxiety, anger, and phobias, she arrived by boat at the Willard dock. Others followed.

The treatment they received wasn't unlike what they would have gotten in other asylums: physical care, unpredictable kindness, food and walls. Sure, some ice baths and isolation were used. Electroshock came at the end of the 1930s, and lobotomy mostly in the 1940s and 1950s. A number of patients stayed for a few years, but a large portion stayed for the entirety of their lives. New York state is notoriously secretive about patients in its hospitals, yet records exist of their ordeal.

Since his US naturalization certificate was in the suitcases, I calculated that Charles F. was born in 1860 and immigrated to America at the age of twenty. After a career, which is how he supported his family of six, his wife surprised him with a divorce. This left him stranded. He pretended to have a routine but, as I envisioned him, the world around him no longer made sense. The most dramatic aspects of his decline came about after a series of letters posted in Poland reached him. World War II had just ended. He had been concerned with the well-being of his siblings in Europe and their children. As much as possible, he sent them money and tried arranging visas for them to come to the United States. But his means were modest, and so were his contacts in higher places.

After years of not uttering a word of Polish—during the early years in America, his primary language was Yiddish, until his children forced him and Leah to speak English to them—he found himself saying a few sentences in it. This made him very uncomfortable. It wasn't an act of will; on the contrary, he described it as automatic. Miriam, his daughter, who read Sigmund Freud, used the word *unconscious*. In any case, the behavior made him feel out of control.

Charles F. arrived at Willard when Harry Truman was president. During his stay, he suffered from severe arthritis. He had poor hearing. But his main problem was his hallucinatory tendency. Doctors diagnosed him as suffering from dementia related to his advanced age, although I'm not convinced that was accurate. I'm not a psychiatrist, obviously, but to me he was just an old Jew adrift in a lost world.

———

The next time I saw Crispin, I asked if I could accompany him to Rotterdam to be part of one of his photo shoots. I wanted to be near Charles F. and familiarize myself as closely as possible with his suitcases.

Crispin agreed and cleared my visit with the museum. He proceeded to explain how the suitcases had emerged and the ongoing curiosity they generated among the public at large. In 1995, as Willard was shutting down, a museum curator by the name of Craig Williams was invited to the attic in the Sheltered Workshop Building, which was adjacent to Chapin House. Also known as the Laboratory, it housed several rooms of medical labs on its first floor; the floors above were used for occupational and recreational therapy.

Williams worked for the New York State Museum in Albany. In an essay called "Fragile History," included in the book *The Changing Face of What Is Normal*, published in conjunction with an exhibition of the same name and investigating concepts of "normality" and "difference" at the Exploratorium in San Francisco, he offered this reminiscence:

> The staff at Willard was proud of its 125 years of care. Willard had long been the primary employer in a very rural area, and its grounds and buildings were very much part of the regional community. Many staff had grown up alongside the facility, and many had parents and grandparents who had worked there as well. In the spring of 1995, the tradition appeared to be coming to an abrupt end. If, as an employee, you were not being transferred to a more distant state facility, you were to be laid off—and most employees were in the latter category.
>
> At the same time, the museum faced key challenges. The fiscal woes of state government that were forcing Willard's closure were also handicapping the museum. Additionally, the museum had never before dealt with the documentation and preservation of such a collection or theme—and certainly not with such short notice. Somewhat reluctantly, the museum's administrators decided to allow the curatorial team to proceed (with a stern reminder about our limited resources). By early March 1995, museum staffers were regularly making the four-hour drive and records had been received, many delivered personally by Willard employees. Willard staffers had prepared detailed lists of possible additional artifacts and led museum personnel through the buildings in a search for things forgotten.

Eager to determine what the museum might be able to rescue, Williams talked to two staffers, Beverly Courtwright and Lisa Hoffman. Courtwright had grown up with the institution—as a child, her family participated in the Family Care program, which, as part of the deinstitutionalization effort, placed patients that were deemed not in need of direct care in nearby private homes (Courtwright once said she had eight aunties in her home). She was tasked with the job to inventory many of the Willard buildings. She unlocked the door to the attic in the Sheltered Workshop Building.

The sheer idea enthralled me. Attics have always exercised enormous allure to me. In Jewish lore, they are linked to the *Geniza*, a secluded room where useless prayer books and other religious paraphernalia are stored. Because they are sacred—and might contain the name of God written in them— they must be kept away from any potential misuse. Once the *Geniza* is full, the community takes out all the items in it and buries them in a secure place. In certain traditions (as in my own congregation), every time someone dies, a few of these religious books are thrown into the grave before the coffin is brought down. Their content will accompany the soul of the departed in its journey of ascendance.

In the Sheltered Workshop Building attic, there were tall, wooden racks. They were divided into two sides. Each rack had three levels. The ones on the left had the sign that read "men"; the ones on the right, "women." The racks stocked suitcases organized alphabetically. They were in all shapes and sizes. They had been placed there between 1910 and 1965. The institutional protocol was clear. After a patient died, their families were notified—if there was information about their relatives, because sometimes the families didn't want anything to do with a sibling or a spouse diagnosed as insane. The relatives were given the option of picking up those belongings at Willard or having them shipped to them at their expense through the postal service. But some couldn't afford either option or couldn't be bothered. The asylum then had to figure out what to do those with those items.

Williams wasn't present in the initial opening of the attic door. As Courtwright later stated, the moment they opened the door a "whoosh of energy came over" her and Hoffman. They saw a beam of sunlight streaming down the center. When Courtwright took Williams to the attic, he realized they had stumbled upon what appeared to be a museum in miniature. He was simply overjoyed. In "Fragile History," he described the scene:

With flashlight in hand, Beverly led the way to the attic of the Sheltered Workshop building, refusing—or perhaps unable to clearly describe—why we were there. It was a part of the building that clearly had not been used in many years. The large open loft in the attic, starkly empty, was faced at the other end with a brick wall. The wall had one door beyond which Beverly refused to go. (She wouldn't even open the door. Beverly had an exceptional sensitivity to Willard's history and people.) Beyond the door were over 400 suitcases dating from the first decade of the 1900s—covered with dust, flecked with pigeon dung, but filled with the presence of their past owners.

 Later, Beverly admitted to not knowing what to do, but knowing what would happen if she told me. Out of respect for their departed owners, she initially felt that perhaps the best course would have been to leave the suitcases undisturbed, letting them be buried in the eventual collapse of the already deteriorating building. My immediate sense was one of awe. And of being privileged to witness these belongings, knowing that they had to be saved quickly.

Williams expressed strong and immediate interest in the treasure trove. But his superiors at the museum told him to keep only about ten of the valises; the rest should be destroyed. Fortunately, he prevailed. Soon, it was arranged for the suitcases to be transferred to the Rotterdam warehouse.

Crispin said that in 2004, an exhibit in Albany featured several of the patients' cases along with some personal information relevant to their lives before, during, and after their time at Willard. It received considerable attention. A few years later, a volume came out that was an outgrowth of the exhibit. It was called *The Lives They Left Behind: Suitcases from a State Hospital Attic*. Its authors, Darby Penney and Peter Stastny, were advocates for a more compassionate treatment of people with mental illness. The book was a sampler of case studies. It had a critical tone to it. For legal reasons, the identities of the patients were hidden behind pseudonyms.

Crispin had started photographing the suitcases in 2011. He said he saw his effort as a way to return the identity to the Willard patients, even though when he requested permission for the project, he was granted it, like Penney and Stastny, on the condition that he not reveal true names. Although this made Crispin uncomfortable, he felt it was better than nothing.

The crisp October morning I spent in Rotterdam with Crispin was emotionally transformative. We walked around the warehouse looking at all sorts of artifacts, including items recovered from Ground Zero after the tragedy of September 11, 2001, in Lower Manhattan. The boxes containing the Willard suitcases were in a nondescript section. There were hundreds, all carefully catalogued.

Clearly, Crispin was in his native habitat. He said to me that according to Courtwright and Williams, every suitcase found in the attic at the Shelter Workshop Building had distilled a numinous power. Afterward, when the collection was brought to the New York State Museum, the valises were cataloged one by one, and everything inside them was preserved archivally. This meant placing smaller items in plastic bags or having larger items wrapped in acid-free paper. That's how they were stored at the warehouse.

Crispin described how in a typical photo session in Rotterdam, he and his assistant, Peggy Ross, would delicately remove the paper and organize the items for each sequence. He spent six to eight hours taking as many pictures as possible, often shooting multiple cases in a day.

In no time, Crispin found the boxes containing Charles F.'s belongings. With care, he unwrapped them, taking out the items and, one by one, placing them on a special table. I loved how that unwrapping unfolded. There was enormous empathy, an emotion I kept experiencing.

Touching Charles F.'s phylacteries, putting on the yarmulke, and reading from one of his *Sidurim*, I thought of how we believe our heartbreaks are unique and unprecedented. But then we come across others, in particular those who follow similar paths to us, and we realize they are as tormented as we are.

In my imagination, I started to visualize Charles F. as a penniless immigrant from Poland who had arrived at Willard in his mid-eighties. Previously he had enjoyed a calm, relatively prosperous life. But then something had happened, something unexplainable, changing the course of his life. In my mind, it wasn't a single event that had triggered his demise but a conflagration of factors.

Bizarrely, that sense of the unexplainable affected me personally in the weeks after my return from Rotterdam. I was part of a series of strange incidents in which I felt as if Charles F. was attempting to speak to me.

One of them was in a dream. In it, I saw him from afar on a rowboat in a lake. I was on the shore. Although we were far apart, he realized a stranger

was observing him, so he looked toward where I was. It was the first time I could see him. He looked like an old teacher of mine in high school who had been an Auschwitz survivor and had immigrated to Mexico in 1952. He looked pale, maybe angry. He had an unkempt beard, which I don't remember my teacher ever sporting.

We didn't say anything to each other at first. Then he uttered a few words about an angel entering an orchard. Actually, four angels. One had died, one had gone mad, one had become an apostate, and one had come back in peace. That's what I remember him saying. The dream was brief. It ended soon after.

Another incident took place a few months later, late at night. I had been working all day and was exhausted but didn't feel like going to bed yet. I decided to prepare tea and toast in the kitchen. When I descended the staircase and looked through the window of the front door, I saw a silhouette outside. It was unlikely that it was real because of the time but also because the figure was almost translucent.

I was frightened but opted to come closer and see if there was indeed someone outside. It was Charles F. The same look as the old man in my dream. I knew it was Charles F., although I can't say why. He had a *Siddur*, which he was about to open. The encounter couldn't have lasted more than a few seconds. Disconcerted, I turned around and left the room.

At first I was puzzled, but in time I interpreted these incidents as a communion. I felt as if Charles F. and I were in dialogue. He was asking me to speak on his behalf.

———

When I spoke to Crispin again, I said I wanted to invent Charles F.'s life using his photographs of the three suitcases as my springboard. It would be not only a feast of the imagination but a way to return some humanity to patient #76086.

Crispin suggested I write to the Office of Cultural Education (OCE) of the New York State Archives, petitioning to access the files of all Jewish patients at Willard. But he cautioned me that New York had one of the strictest confidentiality laws in the nation. Researchers needed to agree not to divulge any personal information about either the patient or the patient's family.

I thought about it. My objective wasn't to divulge any details about Charles F. I wasn't sure I even wanted access to those details. What I was after

was something altogether different: the opportunity of letting him speak through me. Why had he been sent to Willard? What type of family did he have? Where were they while he was institutionalized? Did he forge friendships with anyone? And what defined him as a Jew and as an immigrant?

Still, I followed Crispin's suggestion: I wrote to OCE without mentioning Charles F. specifically. I made the case for researching Jewish life at Willard, for that's what interested me: how Charles F. had communicated his religious longing in those last years. After the dream and the late-night encounter with him, I was sure there was material to be found that would explain the ups and downs of his psychiatric journey. Maybe some of that material pertained to his Jewishness. I attached my résumé to the message to the OCE.

Was I being dishonest?

While waiting for a response from OCE, I did a search in Ancestry.com. I already knew a few basic facts about Charles F. Because his US naturalization certificate was in one of the suitcases, I knew when he had arrived in America. There was a notebook with his handwriting. Crispin told me he had died in 1950 and was buried in Ithaca.

I used the 1940 and 1950 censuses as points of reference. The results were nothing if not maddening. There were scores of Charles F.s. Charles was surely not his Hebrew name. What about Chaim? Or could it be Ya'akov? Ephraim? I typed a number of variations of the F. as a last name: Frenk, Frankel, Franklin, Frankfurter, Frankenheimer.... The onomastic maze made me feel at home since my name is stunningly unstable, too. Depending on the circumstance, people refer to me as Ilan, Ilanchik, Ilanen, Calman, and Kalmen. The word *Ilan* might be spelled Alan, Elan, Illan, Elian, and Ilyian. I am Stavchanskly, Stevansky, Estavchansky, Stafchansky, Stavens, Stevans, Stavas, Stavanz, Esteban, and an assortment of other possibilities.

In narrating Charles F.'s journey at Willard, I could play with the various names he gave himself. After all, immigrants are always changing before others, and the mutability of their names is proof of it.

Anyway, I must have let my secret out—that I really didn't want to know about any Jewish patient at Willard but about just one—because within a couple of weeks I got a response from James D. Folts, head of the Researcher Services at the New York State Archives. In his letter, Folts asked me to be more specific in my petition. Actually, he used firmer language. "The documents you have supplied are necessary for an application to be reviewed by the New York State Office of Mental Health," he stated. "But I must advise you that I think it is highly unlikely that

the agency would designate you and your colleague Jon Crispin as 'qualified researchers,' under mental Hygiene Law sect. 33.1, because your very brief project proposal contains no information about the specific records in the State Archives that you wish to use, and about the research products you envision."

He was right.

I called Crispin to give him the news. I said it was probably a mistake for me to have written to OCE. I could have followed Folt's suggestion, since, as I later found out, quite a few other historians and other professionals have been granted access under similar circumstances. By all accounts the procedure was difficult, but access somehow might be given. Yet in all honesty, I didn't want to know much about the "real" Charles F., in part because what is "real" in a medical dossier amounts to little more than a series of annotations. Humans are only real to themselves and to no one else. What I wanted was to find the magical Charles F., the one beyond any diagnosis or prescription. I wanted to find the Charles F. that in the past few months had been intent on finding me and talking to me directly without interference of any official note.

I said to Crispin that I thought I had three options: (1) I could be more specific with Folts about Charles F.'s life, although that would also probably get me an official denial, since it would be clear I was after the personal information relating to a specific Willard patient; (2) I could make up an even bigger lie about Jewish patients at Willard, but later, if I ever did anything with Charles F.'s information, I would be in trouble; or (3) I could give up my efforts at finding out more specific information at Willard and invent Charles F.'s life through the items in the three valises and an asylum to house him.

It was clear that for me option 3 was the way to go and a liberating path. I would allow my imagination to roam fully free. If I wanted to engage with Charles F., I needed to do it not through historical truth but through the truth that fiction is capable of uncovering. In convincing myself about this route, I thought of Shakespeare, who created Shylock without even ever having seen a Jew, since England had expelled its Jewish population in 1290. He set the plot of *The Merchant of Venice* in an Italian city he had never visited. Shakespeare's whole life was spent between Stratford-upon-Avon, his birthplace, and London, where he was active in the theater scene. In other words, he was a liar.

Walter Benjamin, in his unfinished memoir, *Berlin Childhood around 1900*, says that memory "is

the medium of past experience, just as the earth is the medium in which dead cities lie buried." He says that a person seeking to approach a buried past "must conduct himself like a man digging."

I was letting myself be distracted by other endeavors when one day, maybe a year after I went to Rotterdam, Crispin brought me a present: an enlarged version of his photograph of the suitcase where Charles F. kept his phylacteries. I was moved. Within a few days, I had it framed and hung it on my office wall.

Seeing the picture day in and day out, I understood the urgency of my quest. I realized I was a man digging—and digging hard. I recognized that trying to invent Charles F.'s ordeal at Willard was pushing me, in the depths of my mind, to think about my own connections to mental illness.

———

Edgar Allan Poe once described himself as insane "with long intervals of horrible sanity." Maybe the same applies to me. Insanity is a recurrent theme in my family. How far back it goes, I cannot tell. Digging out those stories frightens me because one of my deepest fears is "losing it," as they say, waking up from an unsettled dream and not knowing who I am, where I come from, and what I'm doing on this Earth. The mind—it's so fragile. You're well put together and then, everything looks chaotic.

Bela, my paternal grandmother, emigrated from a small town in the periphery of Warsaw to Mexico in the 1920s. But she could have ended up in the United States as well. A lottery—that's how immigration works. Although she had a sibling already waiting for her, the sibling could have gone to New York. Or Buenos Aires. Or Palestine. Other siblings never made it out of the hell that Europe became for Jews; they died in Nazi concentration camps.

After her, another sibling, a younger one, came to Mexico. By then, Bela, who had an abrasive temperament, was married. When her youngest sibling—let's call him Natán—started to display interests in books (like me, her grandchild!), she didn't like it. Immigrants shouldn't waste themselves in such unworthy endeavors. They have much to prove. They must work hard and build families that last.

Natán got involved with a *shiksa* and soon she was pregnant. *Oy, gevalt*! For Bela, it was anathema. Was he demented? She threatened him with institutionalization. Other family members interceded. In the end, a better option was found: Natán was sent to Israel, which was a convenient solution: out of sight, out of mind. That's where he died.

I have told the story in my memoir, *On Borrowed Words*. The section about Bela was about how she helped build a home for the family, the opportunities she herself didn't have as a woman at the time, and the way she reacted to others who displayed a creative side. She was admirable; she was implacable, too. Anyone not doing what she wanted was considered insane.

More significant is the journey of my brother, Darian, about whom I also wrote in my memoir. My relationship with him is suffused with pain. Although I love him dearly, I haven't seen him in years. Only when my father died did we communicate again, though only electronically. He didn't go to the funeral or the *shivah*, the seven-day period mourning for the dead.

Darian and I shared a room when we were children. From dawn to dusk, we played *fútbol*. He was a talented pianist. People listened to him. He was a wunderkind with a magical touch. But his behavior was erratic.

He attacked women. He had other frightening explosions of violence, too. For instance, he once came into my parent's home and destroyed everything inside. His life unraveled. For some time, music had been his only outlet; but then that outlet ran thin. Today he lives his own life with his wife, disconnected from everyone else.

I used to judge him. The pain he inflicted on others left expanding circles of suffering. I don't excuse him, but I no longer judge him. I have learned to understand the extent to which he has struggled.

I have even found ways to love Darian anew.

———

The image of Charles F. with a belt around his neck in an attempted suicide made me think of my own suitcases, the ones I metaphorically carry with me. It made me think of the time I became a father and I feared mental illness would continue its journey through the family genes. Every time my children would do something, I would investigate it for its logic, its coherence. Could it be understood as a form of erratic behavior? Isn't childhood about that in general?

I feared becoming paranoid, and I feared my paranoia disturbing the "normal" life of my children.

"Is it possible to stop a line of psychological instability?" I would ask myself. Do we own our own destiny, or is it handed to us? To counteract, I built as rational a routine as possible. My daily routine was—is—a reaction against and a refutation of chaos.

That happened years ago. My children are adults now. They will soon have their own children. Will I interrogate their every act again?

In making up the details that constitute the life of Charles F., I started to conjure a companion: Dr. Sheldon Nuland. Inevitably, the effort was nurtured by my admiration of the relationship between Don Quixote and Sancho Panza in Miguel de Cervantes's novel. It is my favorite book of all time. There is plenty in it I admire, particularly how the two protagonists play on each other's strengths and limitations. But what I like most is that without Sancho, Don Quixote would exist in an utterly solipsistic universe. We wouldn't know who he is, what he thinks, or what his dreams are. The only way into his inner labyrinth is through Sancho's interlocutions.

I felt, in creating Charles F., that in spite of his buoyance, his dementia would prevent the reader from knowing what moves him. But I didn't want Dr. Nuland to be a rigid character. In spite of the inner turmoil hidden under the superficial tranquility moving this character, I was fully aware than in the context of an asylum like Willard, it was unlikely that a doctor would be able to forge a friendship with a patient. There would be too much to distract him. Yet I was also aware that the circumstances I could create—humane, beyond the reductionist parameters of standard psychiatry, would open up a window of possibility. Even in the most unlikely places, people not only find each other but also manage to surprise themselves.

In the first drafts of "What Remains," I rehearsed a number of specific diagnoses Dr. Nuland would write down in Charles F.'s medical dossier. They ranged from depression to schizophrenia. I researched medication and treatments the patient could get and even drafted several scenes in which those interventions—ice baths, for instance—were actually implemented. But in the end I decided against such approach. I didn't want Charles F. to fit a predictable chart. I wasn't doing a critique of the treatment given in mental institutions. What I was after was "a puzzling profile," the spiritual life of an immigrant with a shifting name, whose ingrained Jewish imagery saves him from doom.

To me, Charles F.'s odyssey is about the rapport we create with silence. His hearing diminished dramatically in his final years at Willard. But he learned an invaluable lesson: how to tune the world in and out. He was partially deaf, but he knew how to feign it. I am fond of the section where he tells Dr. Nuland about "the silence of the morgue." And I like the way Charles F. identified himself to the doctor as "a silent man."

Insanity is an alternative approach to sound and silence. Neither better nor worse than so-called normality. Although, of course, it is more barbaric.

A man digging for memories is a man in a heightened state of vulnerability, a man who comes to the realization that nothing in life is fixed. The Earth is never at a standstill but is always shifting. Generations do not cease to be born, and we are responsible to them because we serve as witnesses of the past they will need for understanding who they are. If that past is unavailable, life is senseless. If reason goes out, we go, too.

Reason is light. Reason is order. That order keeps us together. It gives us meaning. We are who we are not because we have shaped ourselves that way but because we have inherited from our genealogical tree whatever legacy we carry within.

Our legacy is our memory. Not knowing that memory is like diving into an ocean of darkness and never coming out.

So in approaching Charles F. through what he left behind, I have fabricated a complete set of memories that could have been my own. I have placed him in the nonexistent asylum inspired by Seneca, a stoic who, seeking to control his own emotions, believed our universe is ruled by a rational providence.

Uncle Natán and my brother Darian are contained in him. And so am I. My roadmap has been the suitcases he left us with, full of items.

True is Charles F.'s tone. True is his pain. True is his disorientation. True is the outrage he suffered in those last four years. The outrage of having been abandoned. The outrage of having been derailed. The outrage of having lost his sense of purpose.

He did everything he could to compensate for that outrage.

I am in awe.

This Is the End

Although the second chapter in Charles F.'s life at Willard is considerably longer than the first—it is made of twice as many months—it is by far less eventful and even serene.

It starts in the aftermath of his suicide attempt.

It took Charles F. twelve days to recover and another seventeen to return to Barrett Hall, first to Ward #3, on the Southern Wing. But then he was again put on Ward #5, on the Northern Wing, in case he suffered from another episode of anxiety.

Dr. Nuland visited him there on Wednesday, September 10. No matter how many questions he asked—"Feeling better? Remember me? How are you?"—it was as if the patient didn't recognize him. Or at least he didn't want to talk. Maybe he had become deaf once more.

Finally, on a third visit a few days later, Dr. Nuland asked: "Are you Bontsha?"

Charles F. smiled.

The next day, he told Dr. Nuland the Maggid had told him to accelerate his death. He also said the Almighty would forgive him for it.

"I'm tired.... I don't want to see the angel anymore."

He indeed looked tired, not like the Charles F. of old times.

"I DON'T WANT TO BE CHARLES," he told Dr. Nuland in a loud voice. "Please. Ya'akov is better. It will bring me quiet. The Maggid won't recognize me. I won't be at his service."

Dr. Nuland recommended that the patient be moved out of Ward #5. "I might be wrong but patient #76086 is unlikely to be unrestrained again anytime soon."

Just as he had predicted, Ya'akov entered a period of relative tranquility. He mostly stayed in his bed. The nurses came in the morning to make sure he ate breakfast, then returned in the afternoon.

A few friends Ya'akov had made while milking cows and in the bowling room—Ethel S., from Arkansas; Rachael P., from Ithaca, New York; and Raphael C., from Washington, DC—visited him. This brought him joy.

For several months, the dossier barely includes anything notable other than comments about diet and amount of medication.

Then, with the "suicidal fit" several months in the past, Dr. Nuland took a three-week vacation the second week of December. When he came back in January, it took a few days to reconnect with Ya'akov.

He knew the patient had been transferred to Hadley Hall. He was ready to visit him when one of the nurses gave him a fresh batch of alarming news.

A day earlier, Ya'akov had left his room at 10:35 a.m. He had a kitchen shift, to which he never arrived. The staff had looked for him all over but

couldn't find him. It appeared as if he had escaped Willard.

Dr. Nuland was distressed. He looked at the patient's dossier. The amount of prescribed lithium was still high. If the nurses had given him the right dose, Ya'akov would probably not get too far. But there remained a staff shortage that was connected with the war. It was common knowledge that jobs outside offered higher pay. The state legislature had recently given salary increases and pay for overtime. But employees still needed to deal with gas and tire rationing.

Maybe Ya'akov had been off his medication.

Dr. Nuland was troubled by the events. When he returned home that evening, there was news of Ya'akov. On the radio, he heard a report about "yet another patient running away into the Finger Lakes," of which Seneca Lake is the largest. As in previous cases, Ovid chief of police assured the population there was nothing to worry about. "It's a male, eighty-seven-year-old patient, unlikely to harm anyone in the community."

Could Ya'akov have taken a train? According to several attendants, he didn't have any money. Might he have jumped into one of the boats on the deck where the *Nautilus* had once regaled the landscape during training classes and sailed to the other side of Seneca Lake? Or could he have driven away with someone in their automobile? Might he have followed the railways? After 1936, the freight service at Ovid Station was still functioning, but passenger service had ended. The track connecting the towns was removed, along with most of the track within the hospital. Buses were available, but Ya'akov didn't think of it. The authorities at Willard speculated that he could have used the freight service, although at his age his mobility was severely limited. A false move and he could die.

It was all suspense for several days.

On the following Monday, September 29, Ya'akov was found a few blocks away from the Ovid County House, at the place of Ms. Janet Farrow, the divorced wife of a postal clerk, "herself known as a cuckoo." It turns out she had taken him in out of pity. Rather than being on the run, as the police though, he was just sitting next to her, the pair of them in front of a radio. What were they listening to? Whatever it was, it made him move back and forth rhythmically. A neighbor who peeked through the window thought "the two people inside were kissing." Knowing that Ms. Farrow lived on her own, the neighbor alerted the authorities.

Two police cars soon descended on the property. As Ya'akov tried to free himself, the police escorted him out. He looked tired. He hadn't eaten in several days. To the *Ovid Daily News*, Ms. Farrow described him as "a sweetheart who is very lonely and just wants company and decent food."

Ya'akov was back at Willard on September 30. He entered through the same administrative building through which he had entered two years before. His dossier states:

> Patient #76086 was working at the kitchen, getting along with other patients and employees. There was no hallucination or delusion at present, but is very argumentative, demanding, and has no insight or judgment. This morning at 8:35am, patient ran away. Found walking on the main hospital street. He was brought back to Barrett House. Stated that his daughter Esther was at the fire house, ready to take him home.

Ya'akov was kept in the infirmary for two and a half weeks.

> Anger and disorientation. Clean and neat in appearance. During the entire interview is deliberately noncommittal, suspicious and evasive. He repeats that his daughter Julia is about to arrive to take him home. He shows some memory deficits. Transferred from Ward 2 to Ward 3 in Barrett Hall in order to give him an opportunity to adjust to a quieter ward.

Was he still fighting his inner demons? Would he be ready to talk about the Maggid? Did he ever resign himself? It depends on what we understand by *a return to the self*. By then Ya'akov was almost a specter. He didn't look of this world.

In spite of Dr. Nuland's pleas, Dr. Kenneth Keil, the medical superintendent in charge of Willard between 1941 and 1961, sent Charles F. to a new section of the asylum. His room was temporarily in the Marconi Annex. It wasn't ideal for patients with chronic illnesses, but a number of facilities at Willard were in a state of disrepair. A motion to demolish a few and build new ones had been in circulation; unfortunately, the state legislature had abandoned the idea.

Ya'akov stayed at the Marconi Annex, in what felt like a closet, for several months. His dossier describes him as "docile, to the point of puppetry."

That attitude frightened Dr. Nuland, who, perhaps because he felt useless, visited the patient less often. He would pat Ya'akov on the shoulder and try to begin a conversation to no avail. Concerned the patient might explode again at any point, Dr. Nuland asked him if he was ready for summer. Cows would need to be milked. Lettuces and tomatoes would need to be planted.

"Charles is back, Dr. Nuland," said Charles F.

Dr. Nuland felt a sudden jolt. Maybe the return of the old self was a sign of improvement.

"I'm glad, Charles. Is Ya'akov okay with his arrival?"

"YES, HE IS."

Charles F. smiled.

Dr. Nuland then read a poem to Charles F. that had been written by W. H. Auden, "If I Could Tell You." It played with two recurring lines, "Time will tell" and "I told you so." Auden combines them into one sentence: "Time will say nothing but I told you so."

Charles F. listened attentively. He asked to have it read again. After Dr. Nuland repeated it, the patient said: "Go ahead and try. Just remember that I told you so."

Sometime in the summer of 1949, Ethel S. talked to one of the Willard nurses. She told her that Charles F. didn't want to be called by that name anymore. He wanted people to refer to him as Chaim F. She and a group of friends that had coalesced around the bowling alley were ready to comply. Except that she was upset because Chaim F. was referring to her as Ida.

"I don't like it."

One afternoon, the same nurse asked Chaim F. not to upset Ethel.

"Ethel and I are getting married."

"You are?"

Chaim F. was quiet. He said his arthritis was worse. He couldn't move his left arm. He wanted to see his daughter Esther.

"She said she was coming tonight."

"Did she?" inquired the nurse.

Chaim F. was quiet again.

What surely contributed to calming down Chaim F. was the World Series. It started on October 5 and ended on October 9. He was mesmerized by the two teams, the Brooklyn Dodgers and the New York Yankees. He looked for news anywhere he could. The fact that the first two games set record attendance at Yankee Stadium made him wish he had

been there. It was thrilling to read the newspaper reports: the Yankees beat the Dodgers 1–0 in the first game and the Dodgers beat the Yankees 1–0 in the second. In Game 3, Luis Olmo and Roy Campanella hit homers in the bottom of the ninth inning. The Yankees won Game 5 with a score of 10–6. It was their twelfth championship in team history. It was the second defeat for the Dodgers in three years.

Chaim F. liked the Dodgers. In his view, it was a "Jewish" team. Obviously he wanted them to be champions, but even the fact that they had lost made them more empathetic to him. Following them was therapeutic. He could forget about his *tzuris*, a Yiddish word he used with Dr. Nuland to describe his condition.

On Tuesday, October 12, 1948, after years of quiet, Chaim's F.'s daughter Esther finally resurfaced. Out of the blue, she shipped him a package with a Passover *Haggadah*. Dr. Nuland took notice; he saved her address and phone number.

An enclosed letter stated that there was definitive evidence that Chaim F.'s only known siblings in Poland, his sister Miriam and brother Ya'akov, had died, probably in the Auschwitz concentration camp. The same fate was suffered by their children. It stated that Chaim F.'s cousin David had been shot in Warsaw by an SS soldier.

In Esther's package was a photograph of what might have been Esther's family in a Passover Seder and a money order for $72.

(Perhaps mercifully, Esther held back several important bits of news; her mother, Leah, had suddenly passed away in Florida not long ago, and Ida Shanholtzer was now in a hospice in Los Angeles.)

Dr. Nuland was alerted about the letter by an administrator. He thought Chaim F. was too fragile to receive the news, so he told the director. But a snafu happened and before he could let the post office know it was better to withhold the letter for a while, it had already been delivered to the patient.

Chaim F. kept the *Haggadah* but threw away the letter; no one is sure he even read it. The money order he didn't notice. A nurse found it after he died. She thought of putting it inside one of his suitcases but never got to do it.

Contrary to what Dr. Nuland expected, Chaim F. didn't manifest any overt reaction. In fact, he looked more quiet than ever. Maybe he was processing the information internally, without sharing it with others. The dossier affirms that "the patient was pleasant and cooperative." There is this transcription:

DR. NULAND: I'm sorry about the news . . .

CHAIM F.: (*Silence*)

DR. N: Do you need to be alone?

CF: (*Silence*)

DR. N: I can't imagine how I would react. . .

CF: To what?

DR. N: My own family dying.

CF: (*Silence*)

DR. N: You're not talking.

CF: No.

DR. N: Are you sleeping well? Are you taking your pills?

CF: I'm kind of tired. I have a pain in my left side.

DR. N: What kind of illness do we treat you for?

CF: Dementia.

DR. N: What do you know about this illness?

CF: I know what I know. And I know that I know, too.

CF: I'm not.

DR. N: Then what are you saying?

CF: Everyone is dead.

DR. N: Do you think everyone is dead?

CF: Everyone is dead.

DR. N: Did you read the letter?

CF: (*Silence*)

The transcription ends there. Dr. Nuland added: "The patient's symptoms are understandable. So much so that I feel like crying. I resist pinning him down to a recognizable diagnosis. There is much more to it than judgment."

In the fall, Chaim F. seemed to be more at peace. He carried a baseball card of Red Sox slugger Ted Williams in his pocket. He said someone in the kitchen, a dishwasher, had given it to him as a gift. Whenever he was anxious, he looked at it. It might even be said that through it he found some inner stasis. He no longer talked about the Maggid.

When they crossed paths outside of Barrett House, Dr. Nuland thought the patient looked like an invalid. He could hardly move. He asked him if he was feeling okay.

"Charles is okay."

The change of pronouns worried Dr. Nuland. As he continued the conversation, he realized Charles F. was only referring to himself in the third person.

"He doesn't think there's much road left. He is tired. He needs to return to school but the teachers are all dead now."

The next day, Dr. Nuland received by mail a copy of a book he had ordered: *Tales of the Hasidim*, by Martin Buber. He had read a review in the *New York Times* and thought it would be a lovely companion for his patient friend.

When he received it, Charles F. was indeed thrilled. He had trouble communicating at that point. Several of his front teeth had fallen out. And he had trouble swallowing food.

He had an unkempt beard, which Dr. Nuland suggested looked like that of a Hasid, a devout Jew.

Charles F. liked the simile.

A couple of days later, he stopped by Dr. Nuland's office. He showed him a Hasidic tale. He wasn't sure if was from the book he had given him as a gift. The doctor read it:

> There was once a king who believed in the stars. One day he read in them that anyone who would eat of the coming harvest would go mad.
>
> He called in his viceroy and friend to ask for his advice.
>
> "My recommendation, Your Majesty," said the counselor, "is that you and I shall only eat last year's harvest, which is untainted. That way we will remain sane."
>
> The king was unpleased. "I don't accept your proposal," he replied. "How can we separate ourselves from our people? To remain the only sane people among a nation of madmen—they will think we are the ones who are mad. Instead, you and I shall eat of the tainted grain, and shall enter into madness with our people."

Then the king thought for a moment: "We must, however, at least recognize our malady," he said. "Therefore, you and I shall mark each other's foreheads with a sign. And every time we look at one another, we shall remember that we are mad."

Seeing that Dr. Nuland was pleased, Charles F. smiled.

"You and I shall mark each other's foreheads with a sign," he said.

Dr. Nuland's overall impression of Charles F. at the time was right: he was tranquil. Yet he failed to notice a more hopeful twist. For it is extraordinary that toward the end, Charles F., his body in rapid decay, was actually more coherent than he had been in at least a decade. He just couldn't communicate that coherence because he was almost completely mute. He had lost his capacity to speak in full sentences. Instead, he used his hands to express even complex ideas.

Dr. Nuland didn't have the patience to follow these ideas. But several other patients did. That's because Charles F. enjoyed three nurturing friendships that returned a jubilant feeling to his heart. One day in early February 1949, he befriended Melanie G., a sixty-two-year-old patient who was

known to have played a couple of minor roles on Broadway. He told her he himself had once been an amateur baseball player. He discussed the fact that Detroit Tiger pitcher Art Houtteman had been badly injured in an automobile crash but recovered to win fifteen games. He told her he was proud the Jewish people now had their own state, soon to turn one year old.

In March, he became close to Vyasa P., who at Willard went by Burro. Originally from New Delhi, Burro had been a prosperous financier in Philadelphia. His family visited him often. With him, Charles F. talked about Mahatma Gandhi and about the partition of India. He believed Gandhi was a saint. Resisting violence with nonviolence was genius.

Charles F. would sit for hours next to a window in the hallway of Winslow Hall. He would tell Melanie G. and Burro that he was sure his wife, Leah, no longer loved him. She had a new husband now. It didn't matter what his name was. Well, actually, he had been his business partner. After he closed the shoe store, he thought he would go into business selling knives. This man, whom Leah knew, was about to open a business in the Bronx. He and Leah had some savings. Maybe it would be a good idea to invest the money in this partnership.

"That money isn't yours anymore," said Melanie G.

"I have it."

"It was confiscated," she responded. "When you enter an asylum, you lose everything."

Charles showed Burro an item he had in his room, in the leather suitcase. It was kept in one of the drawers of his steamer trunk. It was his certificate of naturalization, dated in Brooklyn (Kings County), on October 31, "of the one hundred and twenty-first year of independence of the United States." He said he had become an American at the age of thirty-six.

Charles F. taught Burro how to put out phylacteries for morning prayer. Burro thought he was crazy.

The friendship with Melanie G. was stronger. When seeing Charles F. next to her, more than a few doctors and nurses thought the two were in love. It is possible. By this time his arthritis had become acute. He walked with a cane Dr. Nuland had requested for him. But talking with Melanie G. somehow made him feel better. Even though he didn't hear much, they would laugh out loud.

On Sunday, January 15, 1950, Charles F. began to pray early in the morning and late at night. His *Sidurim* had been left behind somewhere, and he couldn't find them. Dr. Nuland asked a colleague to drive to an Albany synagogue and get new ones.

Around this time, Charles F. became overly concerned with order. Everything in his single room needed to be always neatly organized.

Then, in a lucky strike, during the last months of his life, Margaret Durrell, a fifty-five-year-old nurse, took a liking to Charles F. She was in charge of Ward #4 and had been herself a patient at Willard when she was young. Originally from Chattanooga, she had moved to New York City as a teenager. A psychotic break had landed her in Ward #4, the same place she was now in charge of. After being released, she had gone to nursing school.

Before Willard, she had been a tuberculosis nurse with a job at Biggs Memorial Hospital in Ithaca, from where she was transferred. Her medical dossier at Willard stated: "She is said to annoy people, accusing them of persecuting her, including doctors. The switchboard operator at Biggs is her sworn enemy." But she didn't annoy Charles F., Melanie G., and Gerineldo.

For an hour, she would talk to Charles F. about her life in Tennessee and Charles F. would simply listen. He liked the pitch of her voice.

It was Nurse Margaret who reintroduced Charles F. to the gardener Gerineldo Márquez. Charles F. had met him a few years back. Now the three became inseparable.

Gerineldo was fifty-two, with brown skin and short hair. He lived a couple of miles from Willard and would come a few days a week to tend the grounds. Originally from the Mexican state of Puebla, he had come to the United States as part of the bracero program but when many of his peers returned home, he stayed behind. No one really knew how he had traveled from California to New York or the jobs he had done.

Gerineldo didn't speak a word of English, or maybe just two or three. It was stunning, therefore, that he and Charles F. understood each other so well. Charles F. would tell him everything about his hometown, Vitebsk. He switched to Yiddish to talk about Chagall, how bizarre, magical, and unexplainable his paintings were. Flying brides, horses, and sheep? They looked like Vitebsk, where cows didn't need to be milked because they themselves offered their milk in bottles to anyone who wanted it. The same with eggs and cheese.

In one Chagall painting, there was an angel. White, enormous. The angel, dancing on fluffy clouds, was being painted by the painter. Was that Chagall himself? It was called "The Annunciation." Or maybe "The Visitation."

Charles F. also told Gerineldo and Melanie G. about *Der Dybbuk*. Do you know what happens

when an evil spirit takes possession of you? It lives in your body and won't go away. No matter what you do, you're inhabited by it.

The only solution is to get an exorcist. The exorcist will get the spirit out of your body. You know how? Through prayer and special potions. He once knew a man possessed by the *Yetzer ha-Rah*. The soul of his dead son, who had perished during the war, poisoned by the enemy army, had taken over. There was nothing to do but wait until a rabbi versed in the Kabbalah could address the situation.

Gerineldo looked at Charles F. with puzzlement. He had heard about a case in Veracruz about an *alma en pena*, a wandering soul in need of a home. The soul wandered the world until it found a body. And then it wouldn't leave. A healer had to come to the village and organize a ritual.

Without words, Charles F. indicated he knew what Gerineldo was thinking. Maybe it was the same healer. Did the evil spirit depart?

It did, but it is still wandering around, Gerineldo explained. That's why it is recommended that you don't sing when it's thundering outside. The *alma en pena* might enter your body and refuse to leave. When it thunders, evil spirits take advantage of innocent people. To resist, you need to be devout. Christ will always be at your side. Do you understand?

Charles F. and Melanie G. said yes.

———

Life is an outburst of light bookended by immensities of darkness. What matters are the patterns we make during that outburst, not only for ourselves but for others, and how we build a narrative and the links that narrative leads to.

One Tuesday, as Charles F. sat under a tree outside, Gerineldo was patiently mowing the grass. The gardener was generally wary of approaching the patients at Willard, let alone speaking to them. A neighbor had told him the institution was full of dangerous people, but if he followed the director's instructions and didn't meddle in other people's business, the gardening job would be good.

Charles F. liked the movement Gerineldo made with the scissors. It reminded him of his work at the shoe store. Did he still have the scissors he used for years? Were they in his suitcase or had they been confiscated?

Dr. Nuland found out that, after talking nonsensically, Charles F. had conversed with Gerineldo about the Maggid. He told him, "the Angel who relates liked the way he gardened." He was doing a good job, Charles F. said.

Alone in his room that night, Charles F. thought about Gerineldo again. He convinced himself to try talking to him again the next day. But it rained on Wednesday and again on Thursday. On Friday, when he sat under the tree where he had seen Gerineldo, no one showed up. Charles F. didn't know that it was Good Friday and everyone, including the gardener, was in church.

Nurse Margaret would sit next to both of them and Melanie D. and talk at length. Again, Charles F. didn't hear much of what she said. But he loved the rhythm of her voice and how her words resembled a medley a worker at his shoe store would sing early in the mornings.

The very last time she, Melanie G., Burro, and Gerineldo were near Charles F. was on a cold Thursday afternoon. The sun had set. Somehow, the afternoon light made Willard feel like a movie set. One would be excused for not knowing the asylum was closer to a museum than to a real-life hospital.

Only a handful of administrators knew the institution was at peril. Some medicines were scarce. Two buildings were infested with fleas. And a nurse had drowned in Seneca Lake after a picnic.

On what time frame, on what dimension did Charles F. live at the end of his life, when he could no longer hear what people said, when his joints had all but given up, and his language was a confusion of tenses? Was he trapped in a past with neither beginning nor end? Or in a future he would never see? He didn't live at any specific time. As the inexorable death awaited him, he tried to make sense of his surroundings as best he could but failed. By then everyone in his family had abandoned him. But he wasn't lonely. He had new friends that made him feel like a child.

His dossier is suspiciously silent about the last few months. Did Dr. Nuland, Nurse Margaret, and the rest give up? Had they come to the agreement that whatever symptoms Charles F. was displaying in that period were no longer useful for scientific purposes?

It is true that his thoughts were rambled, that they had no context. Those thoughts belonged to none of the iterations of himself he had experienced in his nine decades on Earth. He wasn't even sure if he owed any money to Willard. How much did a dinner meal cost? Devoured by confusion, with the sound of an ocean delivering persistent waves of nothingness, he realized there was nothing to do but resign himself to whatever next step was scheduled for his body. So he felt a tranquility he didn't remember experiencing, at least not recently. Was he loved now more than ever?

When was the last time he prayed?

Did he take a last look at his belongings just before he departed? In his youth, he had read that Rabbi Akiva, a famous scholar at the time of the

Roman occupation of Palestine and the destruction of the Second Temple in Jerusalem, had died while reciting the *Shema*, the most important prayer in Judaism. In his last days, Charles F. made a wish to the Almighty: to allow him the same fate—to recite the Shema as he let out his last breath.

We don't know if this wish was granted.

Was Charles F. mature enough to understand that love goes through different phases, that it enhances who we are but also diminishes us? How to make sense of the countless accidents his life had been made of, the disrupted currents of coherence he had gone through, following the sparks of anxious disorientation?

He was sure his youthful self was somewhere to be found in the layers of masks he had put on. Did he remember being on the boat near New York City, at the end of the journey he and Leah had made from Russian-occupied Poland, just as the hangman of Vilnius, Mikhail Muravyov-Vilensky, had orchestrated a reign of terror, pushing Jews away, again, just like countless other times in the past?

Making love to Leah had given him happiness. Why didn't it last longer? He recalled how the first time they kissed, he found her lips cold. He recalled feeling ashamed to be seen naked by her even when they already had children. Nakedness, in his eyes, was a private attire.

Did Charles F. remember when Benjamin enlisted in the army and when he and Leah got the telegram about his death in Verdun? Why did Leah refuse to stay next to him when he most needed her? Was she in love with that arrogant neighbor, Meyer Levin? Had he not done everything in his power to make her happy? Is that how she repaid him? He told her and the kids that he didn't want to hear their complaints any more, but it wasn't because he didn't love them. It was because he could literally not hear any more. His ears were tired. They didn't function as they once did. Was that his fault?

We go about our lives as if they were endless, as if death will never come, fooled that whatever is ours will somehow always be so. But nothing really is. Everything around us perishes. Everything is finite, and so are we. The place we have in the world, so much ours, is temporary. It doesn't belong to us. It didn't have us yesterday, and it won't have us tomorrow.

Dr. Nuland noticed that Charles F. died on erev Shabbat, on Friday afternoon, September 29, 1950. He was ninety years old. The Maggid was at his side when he gave his last sigh.

There was a Jewish section in the cemetery at Willard, marked by a sign with a big Star of David. Lawrence Mocha, originally from Austro-Hungarian Galicia, was a patient as well as the institution's

gravedigger. Mocha was asked to make a grave and was ready to start when Dr. Nuland notified him that it was no longer needed. At first, Mocha thought that maybe Charles F. had come back from the dead. But then he heard the body would be transported to another cemetery.

Dr. Nuland located the phone number and contacted Charles F.'s daughter Esther. He told her he and her father had been friends. He thought he heard Esther cry. She asked if there was a hotel nearby and directions on how to get to Willard. Dr. Nuland said she could take the train. He said there used to be a hotel at Willard but no more. There was one nearby, but it wasn't affiliated with the asylum. She would need to make a reservation directly.

Esther called Miriam. Several hours later, she called Dr. Nuland back. She and her sister were too busy to attend the funeral. Miriam said she wanted her father to be buried according to Jewish rituals, if possible the following day, "because Jewish bodies cannot stay above ground longer than twenty-four hours." Dr. Nuland was pleased to hear the request. Miriam asked for a rabbi.

Dr. Nuland told her that other than a local priest, Willard didn't retain any chaplains. But there was a Jewish dentist who worked at the asylum. He lived with his family in nearby Geneva. Through him, Dr. Nuland found a rabbi in Ithaca. When Dr. Nuland called him, the rabbi said he couldn't come to Willard but for a fee the body could be transported to Ithaca. There would be a fee for the cemetery lot.

In the end, Charles F. was buried in Ithaca Cemetery. After his name, his grave simply states: 1860–1950. The grave is under the shadow of a cedar tree.

Dr. Nuland and his wife attended the burial. They held hands. Those in attendance could see she was crying. He, in contrast, could only smile.

On his way back to Willard, a nurse told him about some suitcases that had belonged to Charles F. It wasn't part of the protocol for doctors to look at them before they were returned to the patient's relatives or stored in one of the attics. But since they contained several Jewish artifacts, the nurse wondered if Dr. Nuland wanted to see them. Maybe those items could be donated to a temple.

Dr. Nuland thanked her. He asked to have the suitcase delivered to his office. He would look at them as soon as he could.

They stayed there more than three weeks, though. They had been placed in a corner, behind his desk. Every so often he would look at them from the corner of his eye. But he couldn't make himself open

them until one afternoon, when, just after attending a meeting, he had a few minutes to spare and found himself in his office without knowing what to do.

He opened the suitcases. He found several *siddurs*. He browsed through one, not knowing how to read the Hebrew characters. Could he learn? It would be difficult. He touched several of the shirts and examined the shaving tools. He stumbled upon a bunch of baseball cards. He especially liked the one of Ted Williams.

Mechanically, he placed it inside the *siddur*, then placed the *siddur* on his desk. He would keep these as mementos. He would ask the nurse to reach out to Esther.

The nurse never did: she meant to do it several times but got busy. A few months later, a janitor picked the bags up along with a dozen others also belonging to recently deceased patients. He wasn't known for being careful, and he possibly misplaced a few of the tags, attaching the wrong name to one or two of the suitcases. Worse, one of those suitcases fell apart while he was transporting them to the Sheltered Workshop Building. Fortunately, no one was around to see. Looking at all the dispersed items on the floor, the unlocked the suitcase that was closest to him and dumped inside whatever was at his reach. The rest he threw away.

———

What remains of a person? Nothing remains.

Sooner or later, the constellation of objects that served us as companions loses its order, disappearing into nothingness. This is as it should be. Oblivion is the great equalizer: it devours everything. Human memory is a game of fools. The past is made of fleeting glimpses and silhouettes around which the best we can do is invent imaginary stories.

THE SUITCASES OF CHARLES F. AT WILLARD STATE HOSPITAL

Photographs by Jon Crispin

52

67

70

71

שׁל פּסח

HAGADAH

Passover Seder Service

Prepared by the packers of

MAXWELL HOUSE COFFEE

Good to the last drop

KOSHER FOR PASSOVER

A General Food Product

73

74

של כוס ניסים ולא אפחד כי עזי וזמרת יה ויהי לי לישועה: לי' הי' צבאות אשרי
אברהם ובששון מצעיני אלהי יעקב סלה: לי' צבאות אשרי
עקבנו משגב לנו ברום ישועות ישא וברכה לי' הושיעה
יהוה המלך יעננו ביום קראנו: ליהודים היתה אורה ושמחה
וששון ויקר כן תהיה לנו • כוס ישועות אשא ובשם יי' אקרא:
סברי מרנן ורבנן ורבותי:

ברוך אתה יי' אלהינו מלך העולם בורא פרי הגפן:

על היין

ברוך אתה יי' אלהינו מלך העולם בורא מיני בשמים:

ברוך אתה יי' אלהינו מלך העולם בורא מאורי האש:

ברוך אתה יי' אלהינו מלך העולם המבדיל בין קדש לחול בין אור ל
חשך בין ישראל לעמים בין יום השביעי לששת ימי המעשה: ב
ברוך אתה יי' אלהינו מלך העולם המבדיל בין קדש לחול:

המבדיל בין קדש לחול • חטאתינו הוא ימחול • זר
ענו ירבה כחול: וככוכבים בלילה: יום פנ
אלי גומר • אמר שומר אתא בקר וגם ל
על חטאי עבור תעבור • כיום אתמול
חלפה עונת מנחתי • מי יתן מנו
הבכל לילה: קולי בל יונטל • פתח
טל • קווצותי רסיסי לילה: הע
בנשף בערב יום • בא
חיים תודיעני • מדלות תב
א'

נייע מחזורים זענען מיט צוויי ... אויף די צווייטע זייט שער:
וועלכע זענען אויסגערעכענט

אויך האבען מיר אלעס געדרוקט אויף גרויסע טייטש, כדי עס זאל
יעדער גוט זעהן, און פארשטיין וואס מען דאוונט:

לאדז

בהוצאת בית מסחר הספרים של יצחק שלאמאוויטש
בעיר לאדז, נאוואמיעסקא № 16

Księgarnia i wydawnictwo I. Szlamowicz
Łódź, Nowomiejska 16

DRUK. SIKORA i MYLNER WARSZAWA, NOWOLIPKI 6.

84

GUARANTEED
MADE OF
3 PLY VENEER
VULCANIZED
HARD FIBRE

86

91

95

97

100

PAGES NOT TO BE SHOWN

CERTIFICATE
UNITED STATES OF AMERICA

State of New York, } ss.
COUNTY OF KINGS

Be It Remembered, That at a Term of the County Court of Kings County, held in and for the County of Kings, at the Court House in the City of Brooklyn, on the *Thirty first* day of *October* in the year of our Lord one thousand eight hundred and *ninety-six*

Charles L.

residing within the City of Brooklyn in said County, appeared in his own proper person, in the County Court aforesaid (said Court being a Court of Record, having common law jurisdiction, and a Seal and Clerk), and applied to the said Court to be admitted to become a **CITIZEN OF THE UNITED STATES OF AMERICA,** under the provisions of "Title Thirty" of the Revised Statutes of the United States, which applicant having thereupon produced to the Court

Court to be

IN Whereof, the Seal of the said Court is hereunto

ed, this _31st_ day of _October_

5, in the one hundred and nineteenth year of the

dependence of the United States of America.

William J. Lynch, Dep. Clerk.

104

MEMORY IS A BOX WITHOUT EDGES

A Conversation between Ilan Stavans and Jon Crispin

ILAN STAVANS: In my essay, I describe Charles F. as a silent man. Not in terms of speech. After all, he wasn't mute. Even though he suffered in the last years of his life, he was quite articulate, even vibrant. His silence, in my view, is existential. At a certain point, Charles F. talks to Dr. Nuland about a Yiddish story he read by Yitzhak Leibush Peretz. The story is called "Bontsha the Silent." He doesn't remember it in full detail but is passionate about the plot. The story is about a man who lived his entire life without saying anything significant. Then, when he died and reached the Divine Court, it was discovered by the heavenly creatures that he was what in Judaism is known as a *Lamed Vavnik*, one of the thirty-six just souls every generation needs for the world to continue.

I don't know if Charles F. was a *Lamed Vavnik*. It's possible! I do know, however, that he was a spiritual man. I sense it from the three suitcases he left us with.

JON CRISPIN: The beauty in his suitcases and others in the collection lies in the enigma they convey. The Willard staff put them in an attic for reasons that are still unclear. The fact that they stayed in the Sheltered Workshop Building attic from 1965 to 1995 only enhances the mystery. The seven years I spent photographing those suitcases are like a gift to me.

IS: Thank you for showing me your photographs. They were a revelation.

JC: You are so very welcome. Early on after our meeting in the coffee shop, I knew that you and

Charles F. were connected in some cosmic way. The connection I feel to Charles F. is based on the sensual impressions from touching and smelling his things, then looking at the photographs I made. Neither of us knew him personally. Even if we did, could we ever have known who he really was? What he thought about his life?

IS: We apply logic to understand the world, trusting that everything follows a pattern of cause and effect. But our inner lives have a pattern of their own. Even when we share our inner thoughts, our motivations are a mystery to others. In general, each of us has at least two lives: the one we live on our own, and the one we share with others. I believe there's more.... One of the diagnoses associated with insanity is multiple personality disorder. I believe all of us have it. We are never only one. In the case of writers, we are able to use the multiplicity in our own creations.

JC: In your essay, you have given Charles F. a *possible* life.

IS: As possible as any of the lives we actually live. I also invented an asylum for him. My Willard is inspired in the actual Willard, but it is an entirely autonomous space, with its own metabolism. Creating not only a man out of words but the place he inhabits has been rewarding. That's what art does: it allows us to be like gods.

I want to talk to you about photography as a medium, though. It strikes me as a medium that depends on distance. The photographer is an outsider who closes in a scene and then freezes it. Time stands still in a way that nature never does.

JC: My goal has always been to capture in photographs the emotion in objects. If I'm not engaged with whatever I'm documenting, the viewer won't feel anything either. That the objects representing Charles F.'s life are infused with so much makes my task easier. This is a good time to talk about the process that developed as I began to photograph the suitcases. Before gaining access to the collection, I had no idea how to approach the project. In my mind, I thought all I would have to do was open the cases and there would be a lovely tableau of objects to document. On the first day of shooting, I was faced with the reality of the cases being conserved and cataloged by the New York State Museum. This involved having each item stored in an archival wrap or bag, and the suitcases themselves being wrapped in archival white paper and bound with cotton string. As soon as I put the first case on my fabric background, I knew that I wanted to capture the entire process of the unwrapping sequentially.

It became important to me to show the care with which the museum conserved the objects, and I carried through with this idea during the years that I spent photographing the collection.

IS: In what way is Charles F.'s essence in those valises? What do the objects that surround us tell about who we are? As I finish this sentence, I look up: the room where I am, with two large windows overseeing a beautiful land, is comfortable. It exists because of me. The objects in the room have various provenances. I realize that the moment I disappear, that togetherness will vanish. The objects will no longer have a common stage. In other words, I am the configuration of the world around me. Have I chosen all these items? Not really. They came together as a result of happenstance. But we are a team, at least for now. In fact, I like each and every one of these objects. And although they can't speak, I hope in their way they like me, too. It's an illusion to think that beyond this moment we call "the present," our relationship with the world has any lasting value. The world will belong to others when we are no longer here. They will do what they wish with what we leave behind, as they no doubt should.

JC: That's the answer! Yes—it's all random! Even our own meeting, made possible by an assignment I got from a photo editor at the *New York Times*, was an accident, Ilan.

IS: Talking about randomness, names, too, are arbitrary. The names by which Charles F. was known at Willard seem capricious. Early in my essay (maybe I should refer to it as a story, or else as a *ficción*, the way Borges thought of his nonfictional creations), a pair of New York police officers want to know what his real name is. Charles, Chaim, Chuck, Ya'akov—none feel right. That's because immigrants are amorphous creatures; they resist being pinned down.

JC: I have strong opinions about this topic. New York State has among the strictest privacy laws in the nation regarding people who were institutionalized. They even supersede federal HIPAA laws, which allows for the release of information fifty years after death. In my work with the collection, I'm limited to only using the patients' first names and initial of the surname.

This is still a controversial area. Two sides are easily laid out: protect the privacy of families by not using their names, or use real names to break down the stigma of mental illness, thus giving families an opportunity to learn about their ancestors. The issues, as is clear, are important. The fact that New

York State makes it difficult for relatives to find out about a loved one dehumanizes the patient, especially so long after death.

The issue of revealing Charles F.'s name is fraught with dilemmas for me. During my work, I knew the full names right from the start, as does anyone working at the New York State Museum and able to access the collection. Willard patients were listed by name in the US Census, which is available to the general public, up through the 1940 census. Also, throughout the institution's history, local newspapers wrote articles about specific patients using their full names. And, of course, all of the Willard staff knew the names, and to this day still talk about the patients in a personal way.

As you found out, while provisions are in place at the New York States Archives to access the records, getting permission is very difficult. I have been in those archives. I have read through many of the records of the suitcase owners. And I have photographed them. But like you, early on in my work photographing the cases, I realized I was not interested in exact medical histories. My goal was to give a window into the patients' lives through their possessions.

IS: It certainly has done that—and much more. It has turned me into a man digging for his own and his family's past. Through him, I have recognized my own outsiderness. I'm glad the Office of Cultural Education of the New York State Archives turned me down. That gave me permission to imagine Charles F.'s life without the nuisance of having to chronicle everything exactly as it happened. Instead, I could write about *what could have happened*, which in my mind is equally truthful.

JC: You're right. Even reading his medical charts would not have given you a full picture of his life. Like you have done with your *ficción*, each viewer of my photographs creates a life for him and the rest of the Willard patients.

IS: The irony is that in the age of Facebook, Google, and Twitter, almost nothing personal is personal anymore. Who we are—our names, our phone numbers, our tastes and values, our connections to others—is easily accessible online. Is there anything left in us?

JC: My take on the public/private debate is different than most. I'm off Facebook but still use Instagram, and I post on WordPress. My public profile is determined by the suitcases project though, so if you search for me on the internet, what pops up is Willard. As an artist, that is all I really care about. Who I am as perceived by others

isn't important; I prefer to reveal myself through my photographs.

IS: Looking back, to me the most important feature of Charles F.'s journey is his religiosity. There is a photograph in the suitcases that shows one of his sons in his early twenties. The young man is handsome and well kept. I have imagined him dying of poison gas on the French battlefield during World War I. The death of a child is the most excruciating event that can happen to a parent. Maybe Charles F.'s descent to madness starts there. There are some notes in Charles F.'s suitcases with handwriting that is illegible. I imagine a few more pages with words in English, Yiddish, Polish, Russian, and other languages. In other words, the pages are a Babel-like of possibilities.

JC: Many of the suitcases in the collection contain handwritten documents, which are compelling to me. Patients kept journals while at Willard, wrote and received letters, and made various lists. Pen on paper is an important part of my life, and being able to connect with the suitcase owners through their own writing and through the notes made by Willard staff was a great part of the project.

IS: Charles F. has made me imagine myself marooned in an asylum, cut out from society, secluded because of what? An incapacity to lead a rational life. The question isn't "Will someone remember me?" but "Should I be remembered?" It's a question I ask myself even without the gimmick of the asylum. Who cares what happens after we're gone? We're no longer here, so in concrete terms, it won't affect us. Yet we not only think about it but shape our routine with the hope that something from us, something significant, however small, will last. It might be a foolish thought, but it serves us as traction.

JC: At one time or another, most of us have imagined being institutionalized, whether in an asylum or jail. In the 1980s, when I was documenting four abandoned New York State asylums for my "Silent Voices" project, I spent a lot of time alone in those buildings. It wasn't difficult for me to imagine what life was like while they were in use. Among my many fears, this is not one that takes up much of my time, though. The questions you ask about being remembered are awfully large ones, and while they do apply to what we are doing with this conversation, we don't really have the space to even attempt to answer them. The most compelling aspect of our collaboration for me is that in your writing and in my photographs we are posing these very questions and giving readers the chance to answer them on their own.

IS: As I explore in the middle section, I always feared being imprisoned in a psychiatric ward. In such premises, the dehumanization is complete. This is an issue I wanted to make personal by imagining Charles F.'s life "from within."

JC: For my part, I choose not to personalize this issue, but rather to apply it broadly to Charles F. and the other suitcase owners. With one major exception, though. My son Peter has cerebral palsy and epilepsy. When I read patients' charts or see reference to folks who were institutionalized due to those conditions, it breaks my heart. I was shooting a case of one such patient and felt tears rolling down my cheeks. Had Peter been born forty years earlier to a different family, he would very possibly have been sent to an institution like Willard.

To me, it is quite simple as to how I view the lives of the patients. While the institution saw them as people with a mental illness in need of care by the state, I choose to see them as human beings who led complex, troubled, and interesting lives. My only window into their lives is through the suitcases that came with them to Willard, so that is how I have come to know them. Viewers of the photos will do as I have done, which is to understand these folks through their possessions.

In talking about being remembered and how we view what is in the past, I always come back to Marcel Proust: "Remembrance of things past is not necessarily the remembrance of things as they were." I take it to mean that since all memory is subject to our own bias, we are free to see things as we wish, without worrying about it.

IS: Memory is a box without edges. An invented life, complete with a database of memory that is all a fabrication—is it less real that the life that you and I have? I don't think so. As I make reference to in my essay, Shakespeare created dozens of characters with an astonishing inner life. Lady Macbeth, Hamlet, Prospero, and King Lear in my mind have more complex inner lives than most people. Is that inner torrent of emotions less legitimate because they are invented characters?

JC: This is what excites me about our collaboration. You and I have created a life for Charles F. based on our own experiences. Who is to say whether or not it truly represents who he was?

Even the chance of Charles F.'s suitcases surviving him is so small as to be remarkable. He died without anyone to claim his possessions. You and I have done that.

ACKNOWLEDGMENTS

MY FICTIONAL LIFE of Charles F. and Willard State Hospital benefited from Darby Penney and Peter Stastny's *The Lives They Left Behind: Suitcases from a State Hospital Attic* (2009) and *The Changing Face of What Is Normal: An Exhibition Exploring Concepts of Normality and Difference* (2013), with contributions by Pamela Winfrey, Hugh E. McDonald, Karen L. Miller, Tanya Luhrmann, and Craig Williams.

I perused several other resources: Robert E. Doran's "History of Willard Asylum for the Insane and the Willard State Hospital" (1978); Wayne E. Morrison Sr.'s *Pictorial Album of the Willard Asylum* (1978); Linda S. Stuhler's *The Inmates of Willard, 1879 to 1900: A Genealogy Resource* (2011); Walter Gable's "The Willard Asylum for the Insane" (2018); Hildra R. Watrous's *The County Between the Lakes: A Public History of Seneca County, New York 1876–1982* (1982); Ellen Dwyer's *Home for the Mad* (1987); Braden Johnson's *Unravelling of a Social Policy: The History of the Deinstitutionalization of the Mentally Ill in New York State* (1986); Bonita Weddle's "Mental Health in New York State, 1945–1998: A Historical Overview" (1998); and E. Fuller Torrey's *The Insanity Offense: How America's Failure to Treat the Seriously Mentally Ill Endangers Its Citizens* (2012).

The groundbreaking work of psychiatrists David Greenberg and Eliezer Witztum's *Sanity and Sanctity: Mental Health Work among the Ultra-Orthodox in Jerusalem* (2001) helped me model aspects of Charles F.'s spiritual life.

James D. Folts, head of the Researcher Services at the New York State Archives, promptly responded

to a request for information about Jewish patients at Willard.

For several years, I corresponded with Oliver Sacks, whose case studies in *The Man Who Mistook His Wife for a Hat* (1982) are a cornerstone for empathy in neuroscience. That correspondence is the seed of my work in this volume. I also owe a substantial debt to my late dear friend Sherwin B. Nuland, a.k.a. "Shep," author of *How We Die* (1996). Our extraordinary conversations, sustained over long afternoons, continue to shape my mind.

I delved into my own family history in *On Borrowed Words: A Memoir of Language* (2001).

Gracias to Jonathan Lewis, Craig Williams, and Karen L. Miller for their advice. Austin Sarat at Amherst College created the conditions that helped this endeavor coalesce. The reference librarians at Frost Library in Amherst College were invaluable in their guidance. Susan Bronson, Lisa Newman, David Masower, and the rest of the staff at the Yiddish Book Center in Amherst, Massachusetts, have been incredibly valuable in their support. Annette Hochstein, Nathan Rostron, Arielle Kane, Alison Gore, Rachael Guynn Wilson, and the rest of the staff of Restless Books in Brooklyn, New York, offered essential guidance.

When Rafael Chaiken of SUNY Press found out about *What Remains*, he immediately signed on and has been a guide in the editorial process. His editorial insights permeate every aspect of the book. The publication of this book owes him immensely.

The production editor was Jenn Bennett-Genthner. The manuscript was copyedited by Laura Poole.

—I.S.

Enormous thanks to Craig Williams, curator of the Willard Suitcases for the New York State Museum, who gave me pretty much unlimited access to the collection and supported me in every possible way.

Initially my plan was only to shoot a series on the "most interesting" cases, but my amazing assistant, Peggy Ross, convinced me to photograph the entire collection. It was Peggy who did the heavy lifting as far as organizing the shoots, unwrapping and rewrapping each item, filing them back where they belonged, and keeping a comprehensive database of our work. She was also incredibly useful in helping me with the setups. I could not have done this project without her.

I am grateful to the New York State Museum for providing the space for me to shoot and State Historian Bob Weible, who smoothed over some of the bureaucratic issues that were a big part of the project.

Jeff Stringer, manager of the museum storage facility in Rotterdam, was always cheerful in retrieving the huge boxes of suitcases from their racks and moving them around with the forklift. Museum staffers Connie Frisbee Houde and Aaron Noble are gratefully acknowledged for their interest and help on the project.

Craig Williams introduced me to Dr. Karen Miller, a poet and psychiatrist, who helped me understand the lives of the patients in ways I could never have imagined. Her poems offer an insight into the suitcase owners that are both moving and inspirational.

Thanks to the 1,015 backers of my two Kickstarter appeals, whose encouragement and financial support funded my work, and to filmmaker Peter Carroll, whose sensitive videos helped explain the project.

Thanks to Mary Hardiman of the *New York Times*, who gave me the assignment to photograph Ilan Stavans in 1999. Without that connection, *What Remains* might never have happened.

Just about everything I do as a photographer is influenced by my friend and mentor Alex F. Ross. Thanks, Ace.

Finally, thanks to my wife, Cristine Smith, and our son, Peter, who provide the love, stability, and encouragement that allow me to do what I do.

—J.C.

ILAN STAVANS is Lewis-Sebring Professor of Humanities, Latin American, and Latino Culture at Amherst College, the publisher of Restless Books, and the host of the NPR podcast *In Contrast*.

JON CRISPIN is an internationally renowned photographer living in Amherst, Massachusetts.